Heraldic Designs for Artists and Craftspeople

John M. Bergling

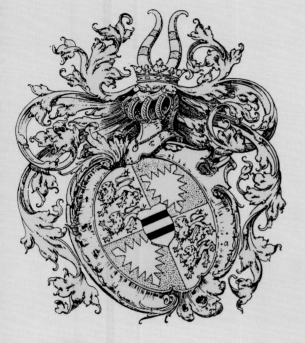

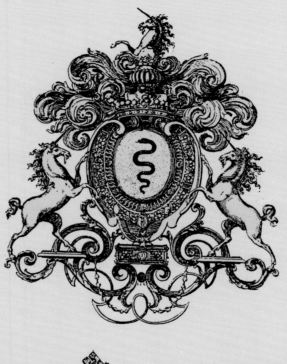

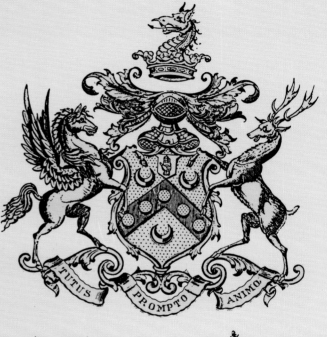

Spofford

RATHER DEATHE THAN FALSE OF FAYTHE

With Over 1400 Illustrations

TUTUS PROMPTO ANIMO

DOVER PICTORIAL ARCHIVE SERIES

(continued on back flap)

HERALDIC DESIGNS
FOR ARTISTS AND CRAFTSPEOPLE

John M. Bergling

DOVER
PUBLICATIONS, INC.
Mineola, New York

1997

Bibliographical Note

This Dover edition, first published in 1997, is an unabridged republication of *Heraldic Designs and Engravings for the Workshop, Studio and Library*, published by the designer, J. M. Bergling, Chicago, 1913. The introductory Note was prepared specially for this edition.

DOVER *Pictorial Archive* SERIES

Library of Congress Cataloging-in-Publication Data

Bergling, J. M. (John Mauritz), 1866–1933.
 [Heraldic designs and engravings for the workshop, studio, and library]
 Heraldic designs for artists and craftspeople / John M. Bergling. — Dover ed.
 p. cm.
 Originally published: Heraldic designs and engravings for the workshop, studio, and library. Chicago, 1913. With new introd.
 ISBN 0-486-29663-6 (pbk.)
 1. Crests. 2. Heraldry in art. 3. Heraldry. 4. Heraldry— Dictionaries. I. Title.
CR55.B47 1997
929.6—dc21 96-49780
 CIP

Manufactured in the United States of America
Dover Publications, Inc., 31 East 2nd Street, Mineola, N.Y. 11501

Heraldry is the art of designing and regulating the symbols ("armorial bearings") used to distinguish individuals and institutions, a practice that saw its beginnings in twelfth-century Europe. Heraldry's language is a conjoining of the identificatory markings displayed on the shields and surcoats of armored knights, and the emblems on seals used to authenticate documents. Initially heraldic devices were simple in design, for it was imperative to the knight in battle that his arms could be read at a glance by his comrades. With the introduction of first the longbow and then artillery to warfare, however, the use of mounted warriors waned, and with it the martial applications of heraldry; away from the battlefield, the coat of arms came to be seen as a sign of social distinction rather than as a practical device, and its visual and verbal language subsequently grew sophisticated and elaborate.

Whereas the heraldic device was once comprised primarily of a shield alone, today it may incorporate a number of different elements. A contemporary design will usually contain the following components: (1) the shield, on which the bearer's arms are displayed; (2) the helmet, positioned above the shield; (3) the crest, surmounted on the helmet and attached by a wreath matching the colors of the shield; (4) the mantling or lambrequin, hanging from the helmet and also matching the shield's principal colors; (5) the crown, coronet or chapeau, designating the bearer's social rank; (6) the motto, usually set on a scroll beneath the shield; (7) the supporters, comprising the figures on either side of the shield; and (8) the compartment, the base or foundation on which the supporters stand.

The shield itself consists of the "field," or surface, and the "charges" upon it. There are three kinds of fields: (1) the five colors or tinctures—azure (blue), gules (red), vert (green), sable (black) and purpure (purple); (2) the two metals—or (gold) and argent (silver); and (3) the furs—ermine (a white field with black spots), ermines (black with white spots), erminois (gold with black spots), pean (black with gold spots) and vair (blue and white). As a general rule, combinations may be made between but not within the three categories. The field serves as a background upon which objects may be "charged" or displayed.

The charges themselves may be of two kinds: ordinaries (so called because their use is so common) and minor charges, those less frequently used. The heraldic vocabulary continues to grow with the latter, and today a newly commissioned armorial device might be charged with a depiction of an aircraft, a car or any number of other modern contrivances.

In the present collection of more than 1,400 designs, J. M. Bergling has brought together family coats of arms, the emblems of businesses and societies, and the seals of various states and nations, as well as a number of different elements that might be joined in making up a heraldic device; also included is the author's original essay on the origin and employment of armorial designs, and a sampling of different alphabets suitable for use in a coat of arms. The figures found herein may be used for inspiration or imitation, to embellish book designs, to ornament bookplates and labels or to spruce up stationery. They also provide a rich source of copyright-free motifs for graphic designers and artists.

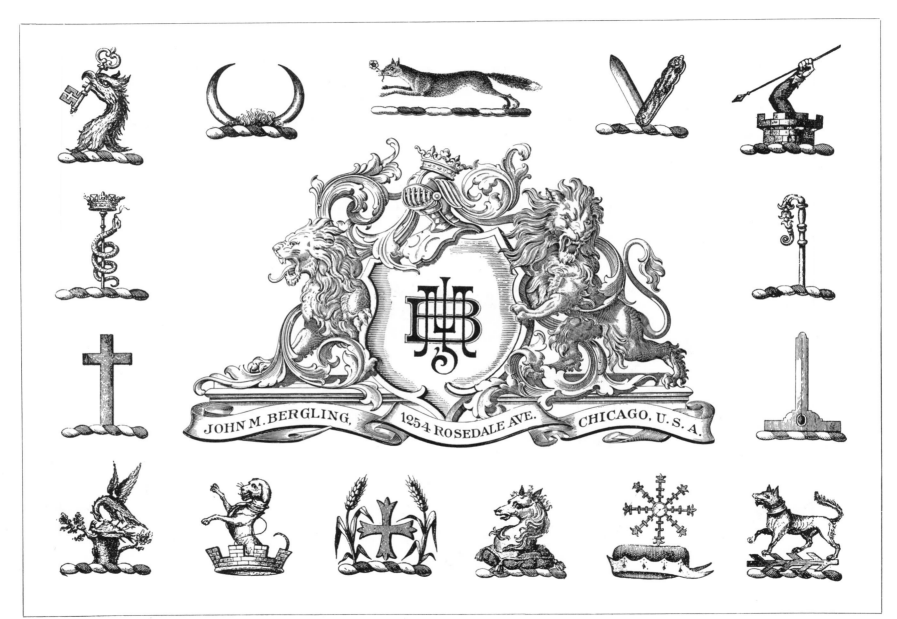

JOHN M. BERGLING, 1254 ROSEDALE AVE. CHICAGO, U.S.A.

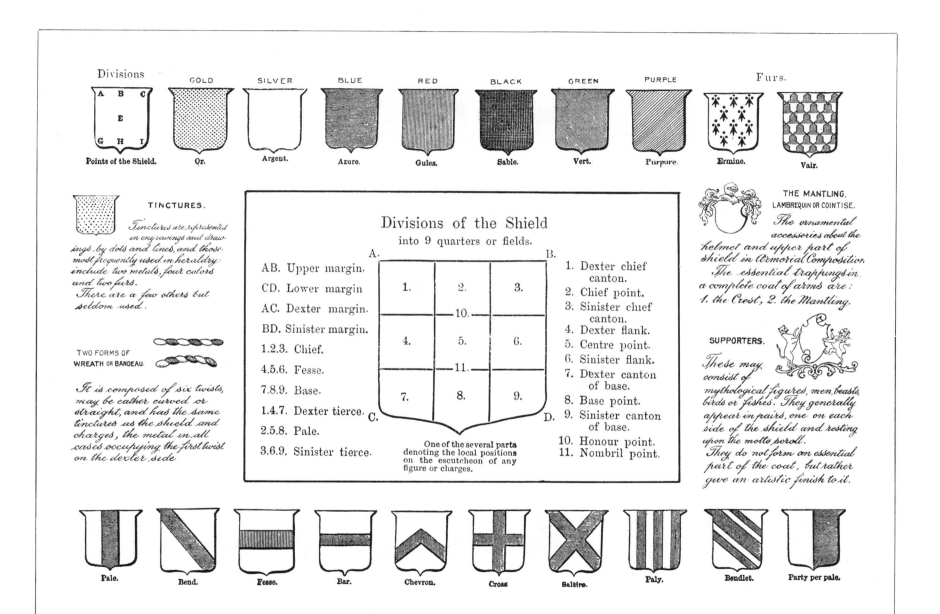

Divisions — GOLD — SILVER — BLUE — RED — BLACK — GREEN — PURPLE — Furs.

A B C / E / G H I — Points of the Shield. — Or. — Argent. — Azure. — Gules. — Sable. — Vert. — Purpure. — Ermine. — Vair.

TINCTURES.

Tinctures are represented in engravings and drawings by dots and lines, and those most frequently used in heraldry include two metals, four colors and two furs. There are a few others but seldom used.

TWO FORMS OF WREATH OR BANDEAU.

It is composed of six twists, may be either curved or straight, and has the same tinctures as the shield and charges, the metal in all cases occupying the first twist on the dexter side

Divisions of the Shield
into 9 quarters or fields.

AB. Upper margin.
CD. Lower margin
AC. Dexter margin.
BD. Sinister margin.
1.2.3. Chief.
4.5.6. Fesse.
7.8.9. Base.
1.4.7. Dexter tierce.
2.5.8. Pale.
3.6.9. Sinister tierce.

A. ... B.
1. | 2. | 3.
10.
4. | 5. | 6.
11.
7. | 8. | 9.
C. ... D.

One of the several parts denoting the local positions on the escutcheon of any figure or charges.

1. Dexter chief canton.
2. Chief point.
3. Sinister chief canton.
4. Dexter flank.
5. Centre point.
6. Sinister flank.
7. Dexter canton of base.
8. Base point.
9. Sinister canton of base.
10. Honour point.
11. Nombril point.

THE MANTLING, LAMBREQUIN OR COINTISE.

The ornamental accessories about the helmet and upper part of shield in Armorial Composition. The essential trappings in a complete coat of arms are: 1. the Crest, 2. the Mantling.

SUPPORTERS.

These may consist of mythological figures, men, beasts, birds or fishes. They generally appear in pairs, one on each side of the shield and resting upon the motto scroll. They do not form an essential part of the coat, but rather give an artistic finish to it.

Pale. — Bend. — Fesse. — Bar. — Chevron. — Cross. — Saltire. — Paly. — Bendlet. — Party per pale.

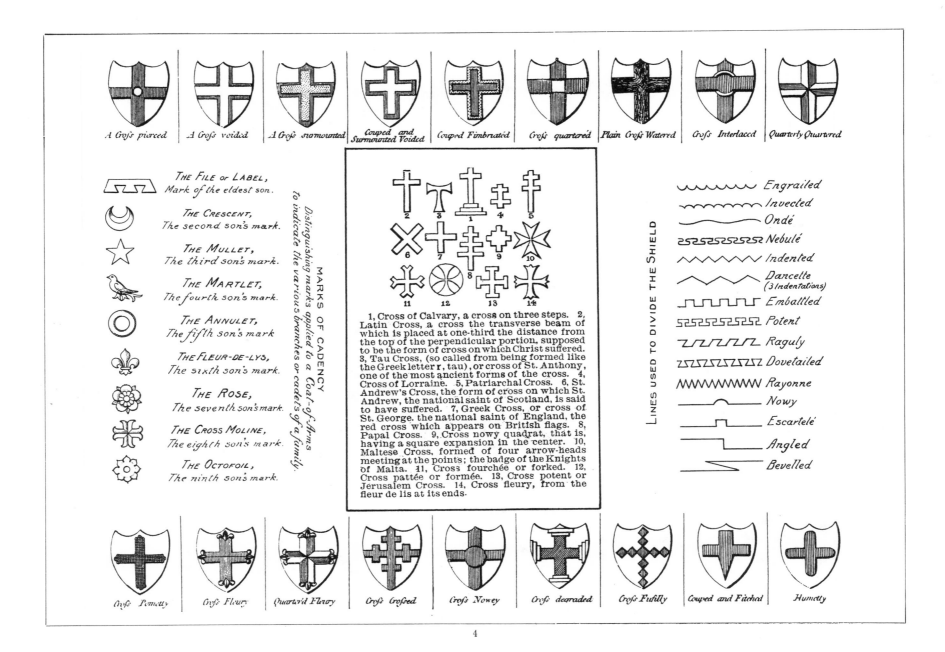

A Cross pierced | A Cross voided | A Cross surmounted | Couped and Surmounted Voided | Couped Fimbriated | Cross quartered | Plain Cross Watered | Cross Interlaced | Quarterly Quartered

MARKS OF CADENCY
Distinguishing marks applied to a Coat-of-Arms to indicate the various branches or cadets of a family.

THE FILE or LABEL,
Mark of the eldest son.

THE CRESCENT,
The second son's mark.

THE MULLET,
The third son's mark.

THE MARTLET,
The fourth son's mark.

THE ANNULET,
The fifth son's mark

THE FLEUR-DE-LYS,
The sixth son's mark.

THE ROSE,
The seventh son's mark.

THE CROSS MOLINE,
The eighth son's mark.

THE OCTOFOIL,
The ninth son's mark.

1, Cross of Calvary, a cross on three steps. 2, Latin Cross, a cross the transverse beam of which is placed at one-third the distance from the top of the perpendicular portion, supposed to be the form of cross on which Christ suffered. 3, Tau Cross, (so called from being formed like the Greek letter τ, tau), or cross of St. Anthony, one of the most ancient forms of the cross. 4, Cross of Lorraine. 5, Patriarchal Cross. 6, St. Andrew's Cross, the form of cross on which St. Andrew, the national saint of Scotland, is said to have suffered. 7, Greek Cross, or cross of St. George. the national saint of England, the red cross which appears on British flags. 8, Papal Cross. 9, Cross nowy quadrat, that is, having a square expansion in the center. 10, Maltese Cross, formed of four arrow-heads meeting at the points; the badge of the Knights of Malta. 11, Cross fourchée or forked. 12, Cross pattée or formée. 13, Cross potent or Jerusalem Cross. 14, Cross fleury, from the fleur de lis at its ends.

LINES USED TO DIVIDE THE SHIELD

Engrailed
Invected
Ondé
Nebulé
Indented
Dancette (3 Indentations)
Embattled
Potent
Raguly
Dovetailed
Rayonne
Nowy
Escartelé
Angled
Bevelled

Cross Pometty | Cross Fleury | Quarter'd Fleury | Cross Crossed | Cross Nowey | Cross degraded | Cross Fusilly | Couped and Fitched | Humetty

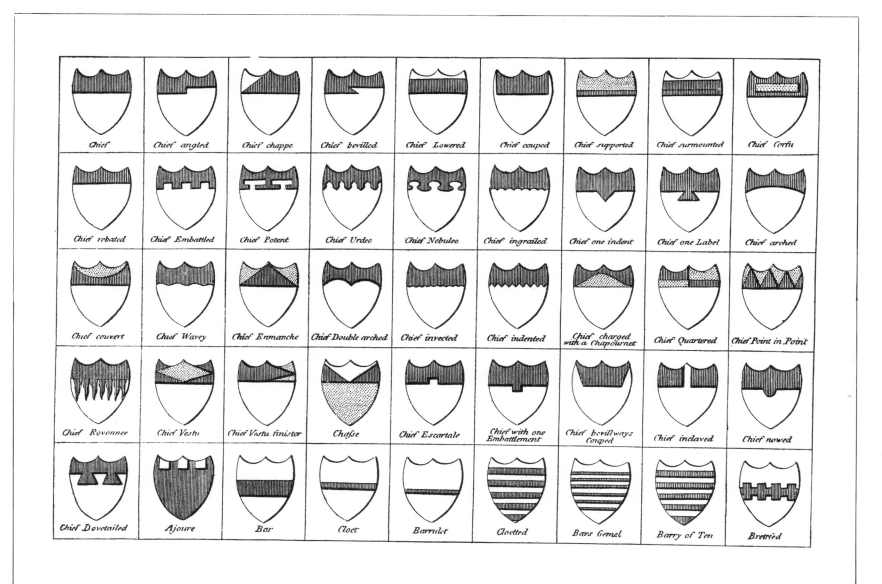

Chief	Chief angled	Chief chappe	Chief bevilled	Chief Lowered	Chief couped	Chief supported	Chief surmounted	Chief Corfu
Chief rebated	Chief Embattled	Chief Potent	Chief Urdee	Chief Nebulee	Chief ingrailed	Chief one indent	Chief one Label	Chief arched
Chief couvert	Chief Wavey	Chief Enmanche	Chief Double arched	Chief invected	Chief indented	Chief charged with a Chapournet	Chief Quartered	Chief Point in Point
Chief Rovonnee	Chief Vestu	Chief Vestu sinister	Chasse	Chief Escartale	Chief with one Embattlement	Chief bevillways Couped	Chief inclaved	Chief nowed
Chief Dovetailed	Ajoure	Bar	Cloet	Barrulet	Cloetted	Bars Gemel	Barry of Ten	Brettied

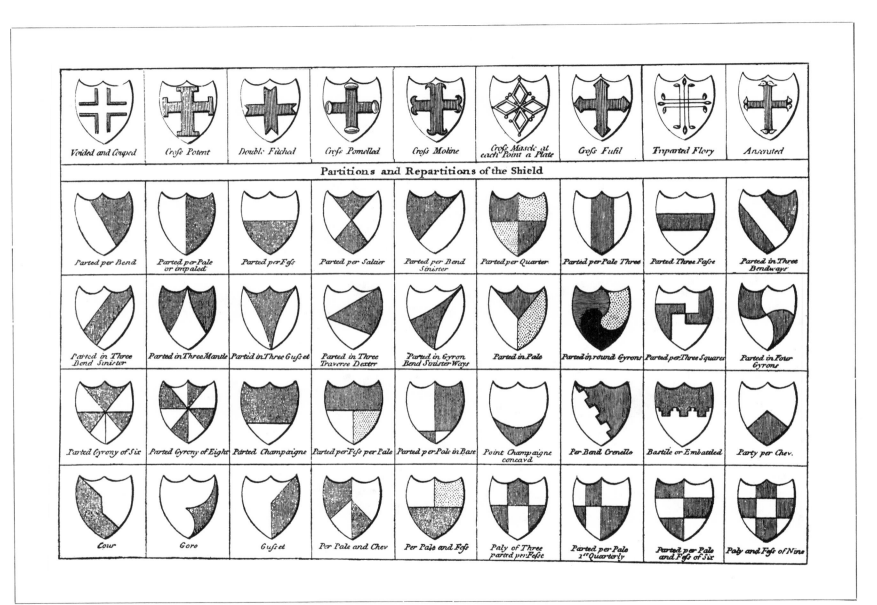

Voided and Couped	Cross Potent	Double Fitched	Cross Pomelled	Cross Moline	Cross Masele at each Point a Plate	Cross Fusil	Triparted Flory	Anserated

Partitions and Repartitions of the Shield

Parted per Bend	Parted per Pale or impaled	Parted per Fess	Parted per Saltier	Parted per Bend Sinister	Parted per Quarter	Parted per Pale Three	Parted Three False	Parted in Three Bendways
Parted in Three Bend Sinister	Parted in Three Mantle	Parted in Three Gusset	Parted in Three Traverse Dexter	Parted in Gyron Bend Sinister Ways	Parted in Pale	Parted in round Gyrons	Parted per Three Squares	Parted in Four Gyrons
Parted Gyrony of Six	Parted Gyrony of Eight	Parted Champaigne	Parted per Fess per Pale	Parted per Pale in Base	Point Champaigne concavd	Per Bend Crenello	Bastile or Embatiled	Party per Chev.
Cour	Gore	Gusset	Per Pale and Chev	Per Pale and Fess	Paly of Three parted per Fesse	Parted per Pale 2 Quarterly	Parted per Pale and Fess of Six	Paly and Fess of Nine

6

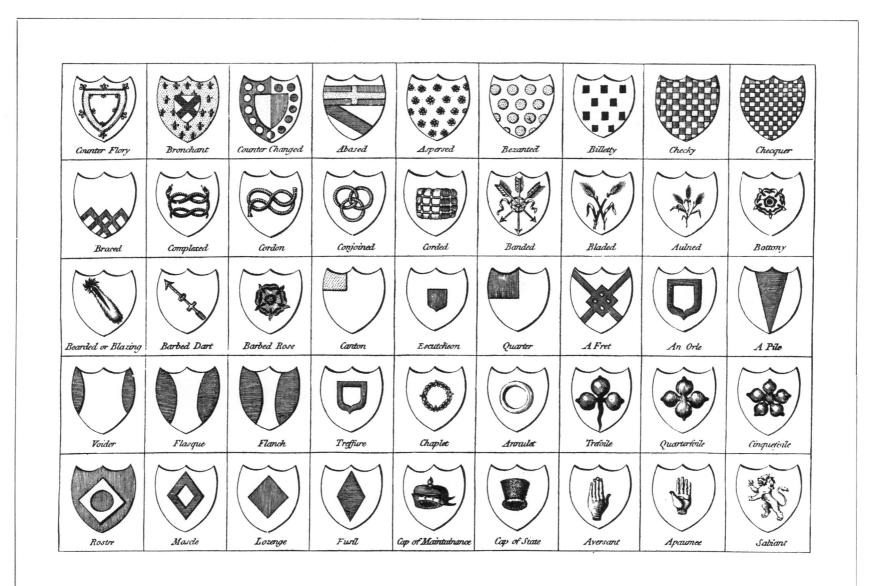

Counter Flory	Bronchant	Counter Changed	Abased	Aspersed	Bezanted	Billetty	Checky	Checquer
Braced	Complexed	Cordon	Conjoined	Corded	Banded	Bladed	Aulned	Bottony
Bearded or Blazing	Barbed Dart	Barbed Rose	Canton	Escutcheon	Quarter	A Fret	An Orle	A Pile
Voider	Flasque	Flanch	Treffure	Chaplet	Annulet	Trefoile	Quarterfoile	Cinquefoile
Rostre	Mascle	Lozenge	Fusil	Cap of Maintainance	Cap of State	Aversant	Apaumee	Sabiant

7

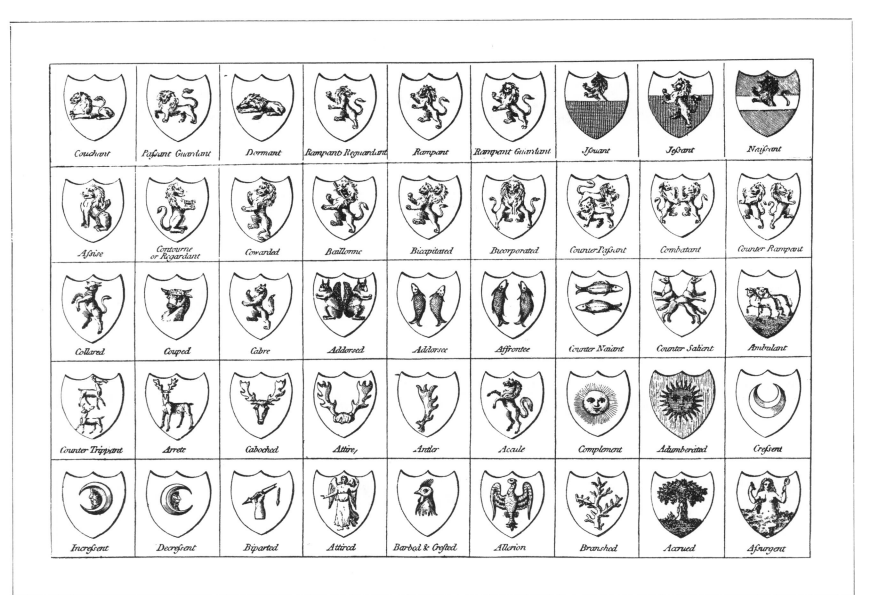

Couchant	Passant Guardant	Dormant	Rampant Reguardant	Rampant	Rampant Guardant	Issuant	Jessant	Naissant
Assise	Contourne or Regardant	Cowarded	Baillonne	Bicapitated	Bicorporated	Counter Passant	Combatant	Counter Rampant
Collared	Couped	Cabre	Addorsed	Addorsee	Affrontee	Counter Naiant	Counter Salient	Ambulant
Counter Trippant	Arrete	Caboched	Attire,	Antler	Accule	Complement	Adumberated	Cressent
Incressent	Decressent	Biparted	Attired	Barbed & Crested	Allerion	Branshed	Accrued	Assurgent

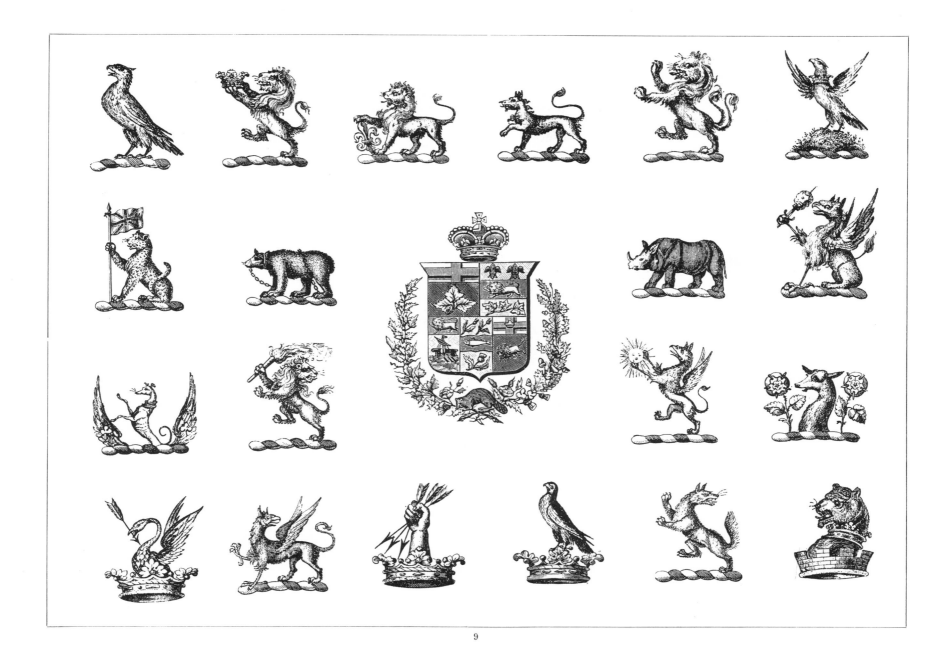

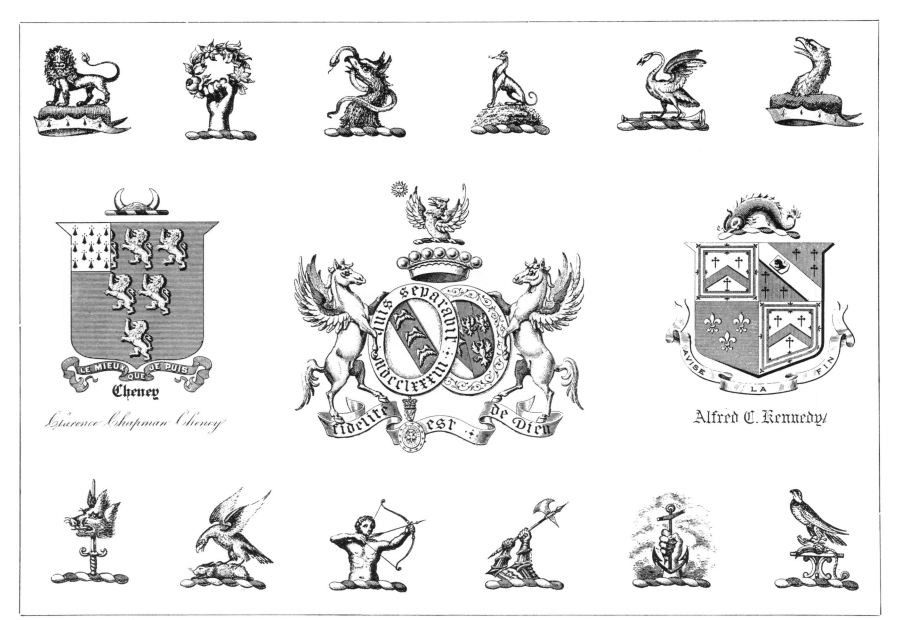

Cheney

LE MIEUX QUE JE PUIS

Clarence Chapman Cheney

Alfred C. Kennedy

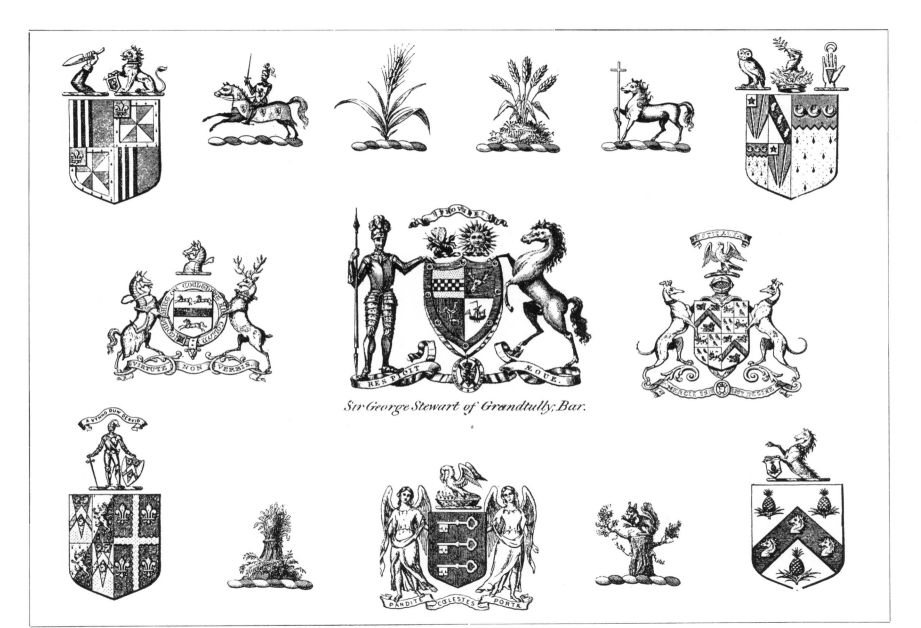

Sir George Stewart of Grandtully, Bar.

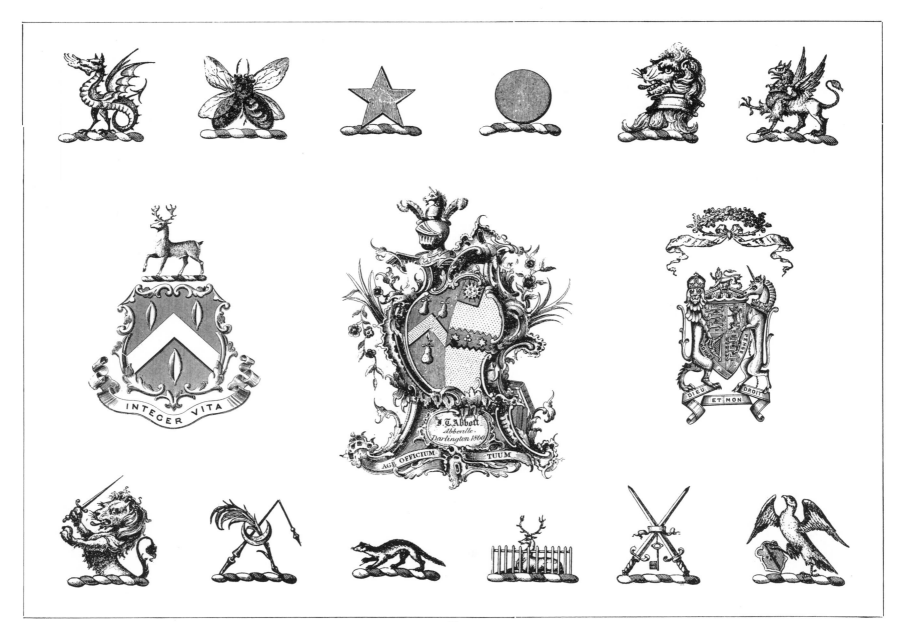

INTEGER VITA

J. T. Abbott
Abbeville
Darlington 1860

AGE OFFICIUM TUUM

DIEU ET MON DROIT

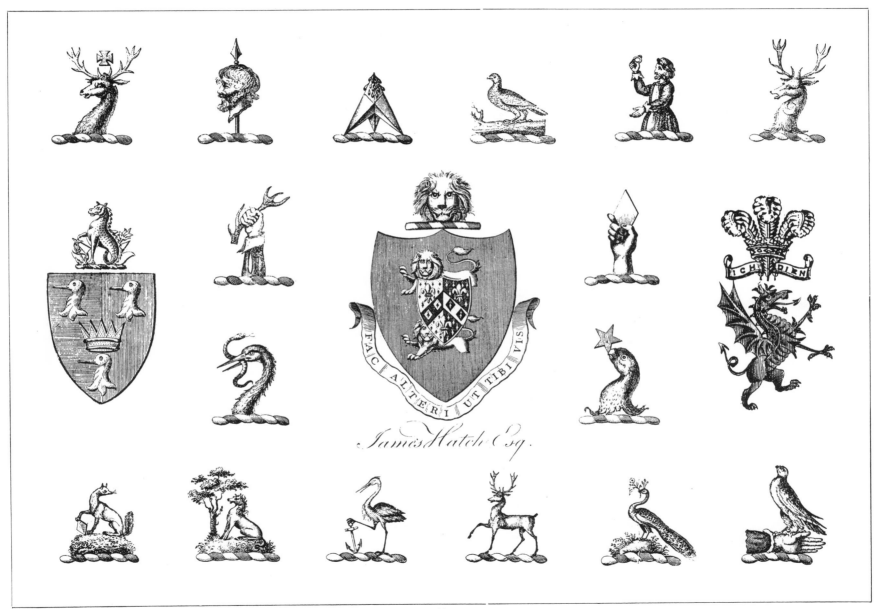

FAC ALTERI UT TIBI VIS

ICH DIEN

James Hatch Esq.

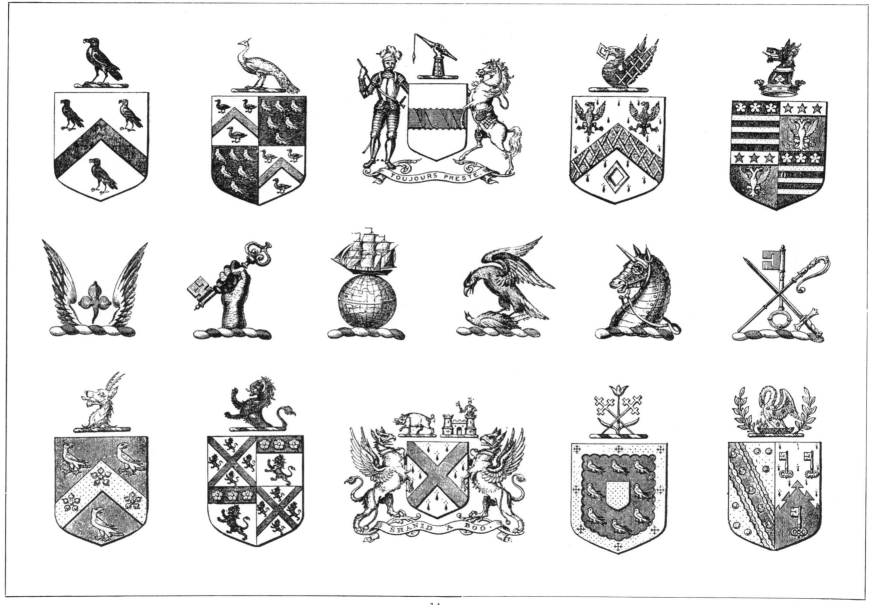

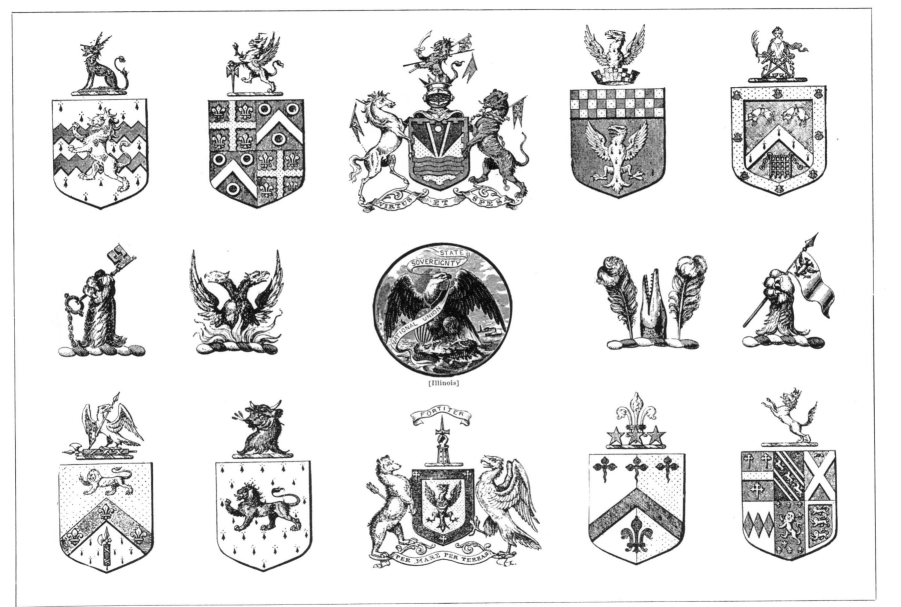

[Illinois]

15

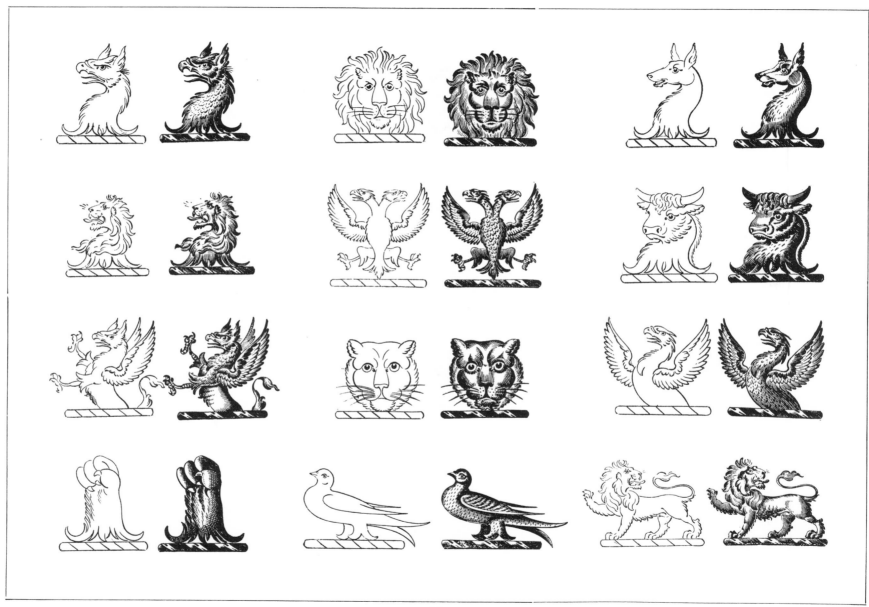

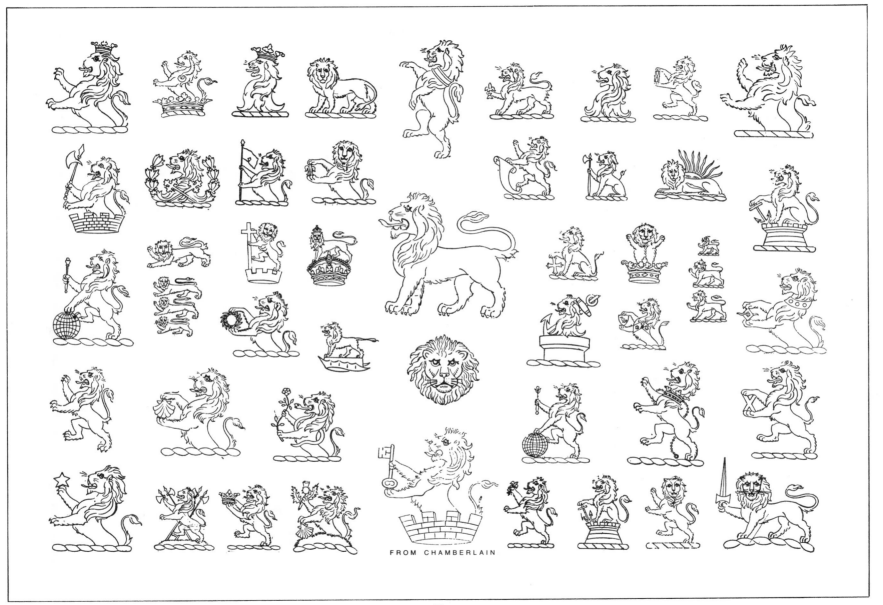

FROM CHAMBERLAIN

17

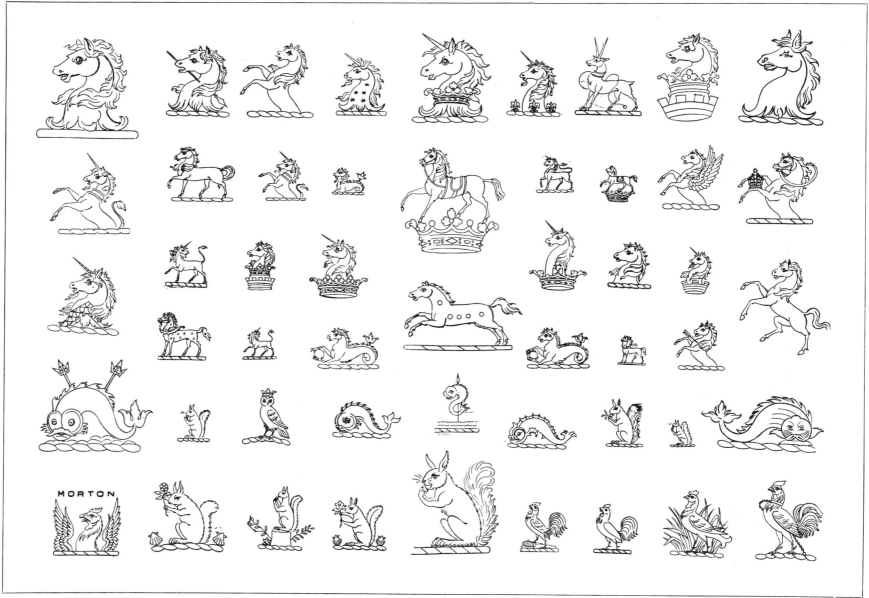

MORTON

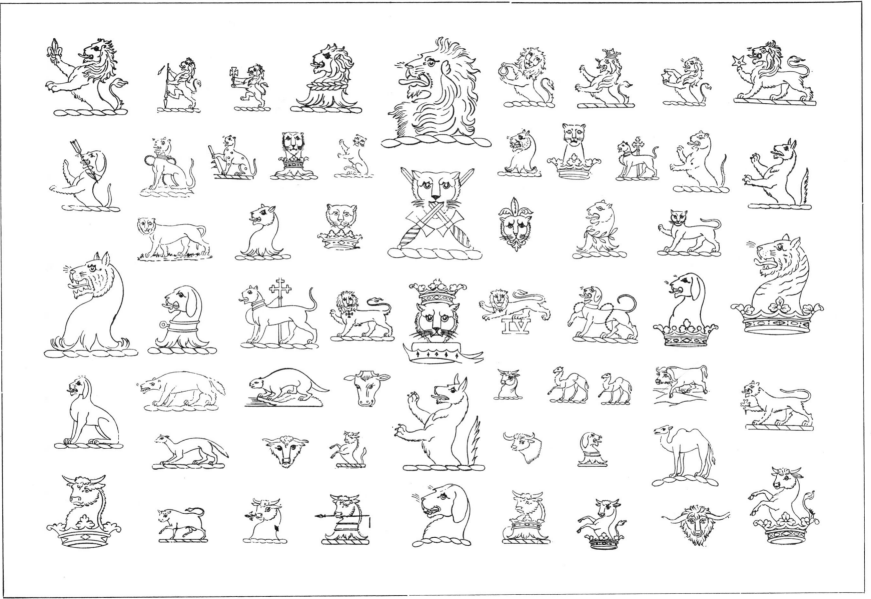

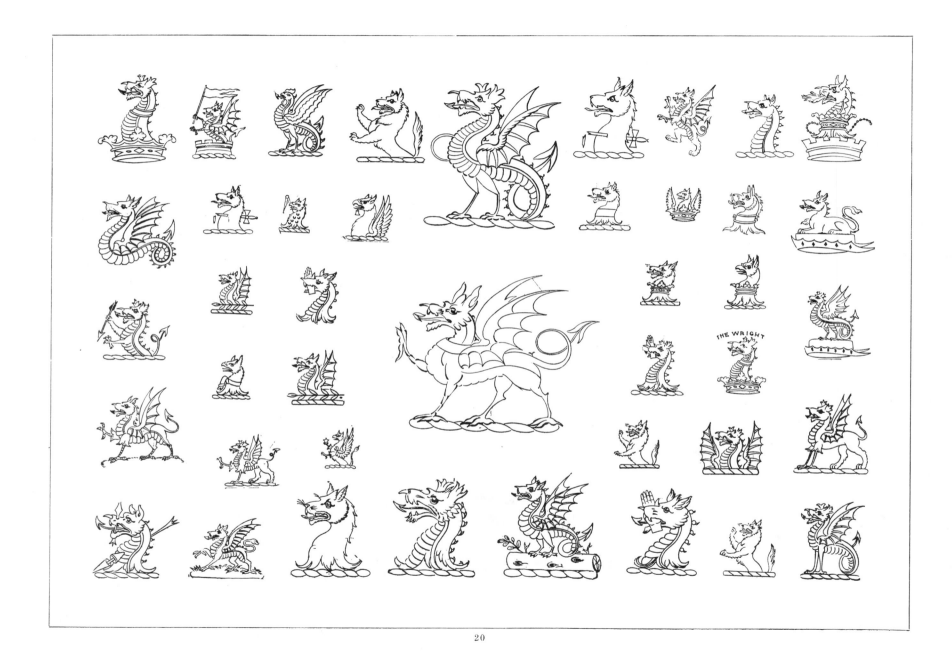

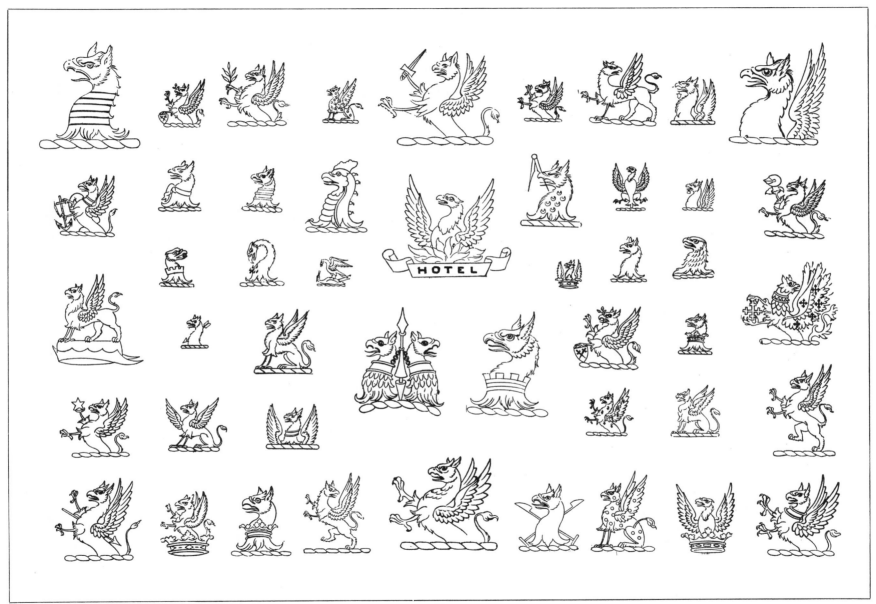

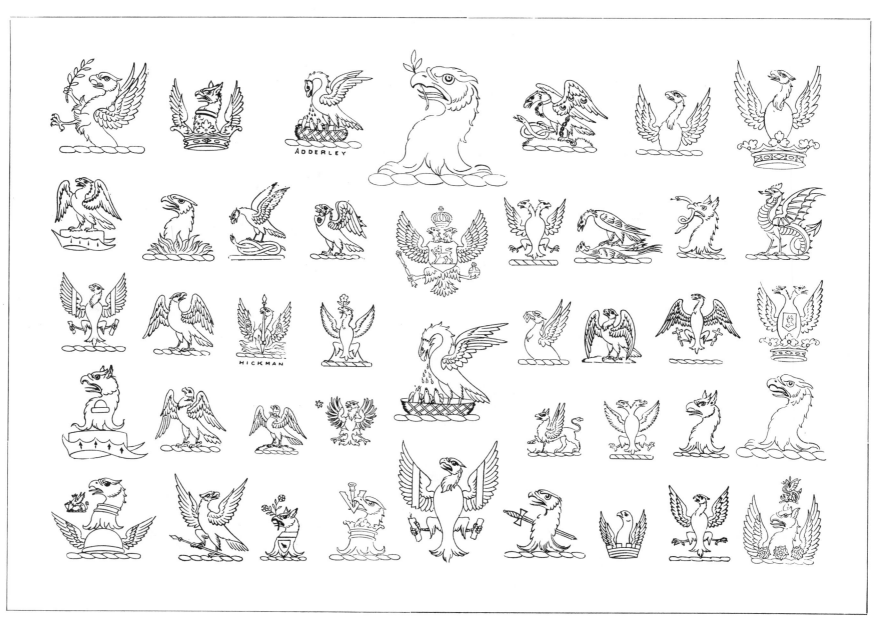

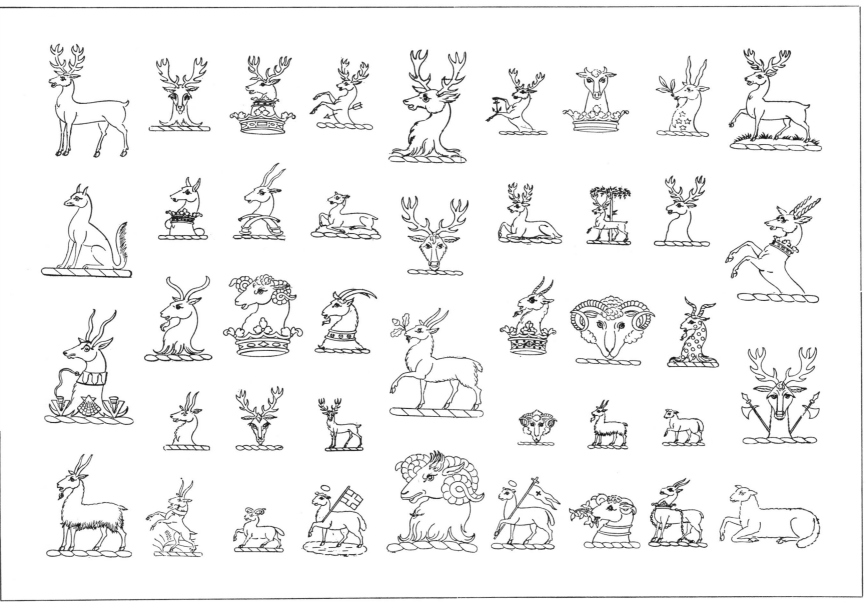

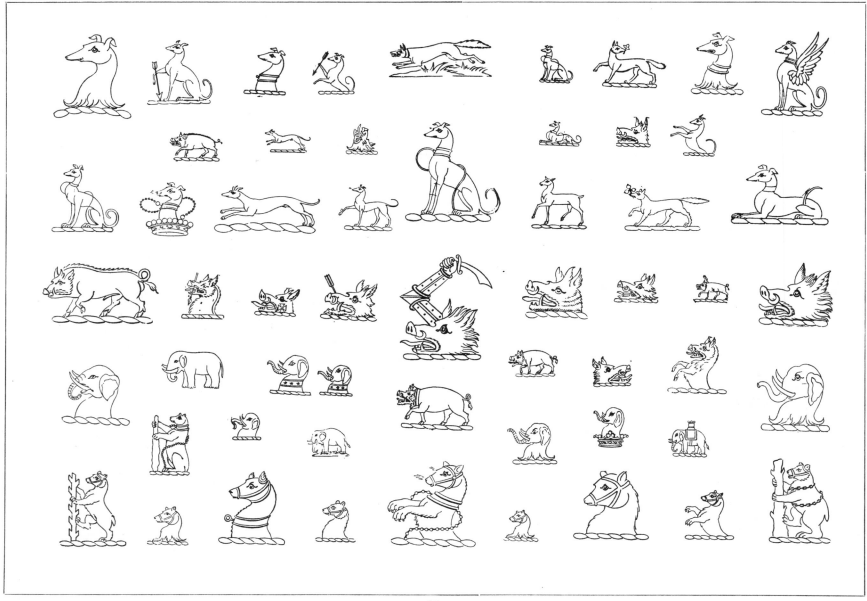

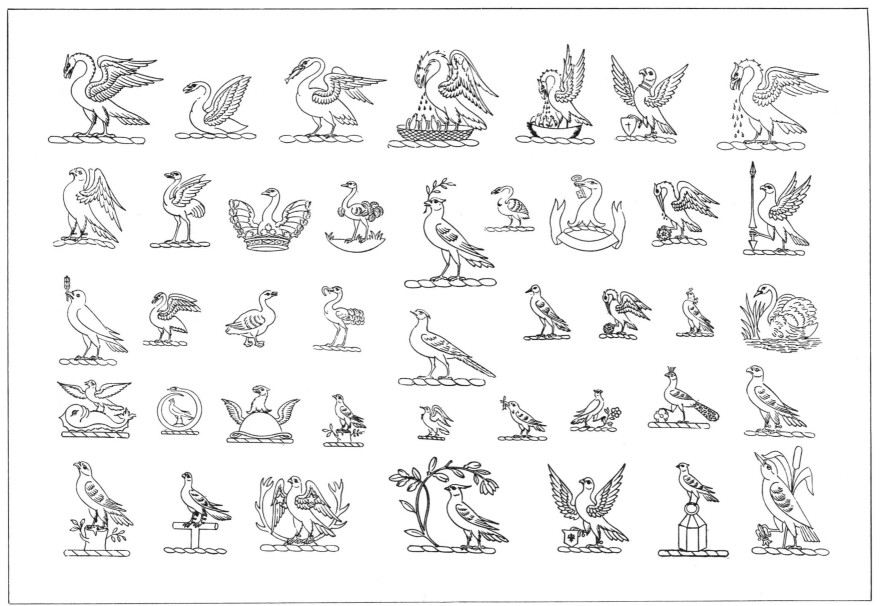

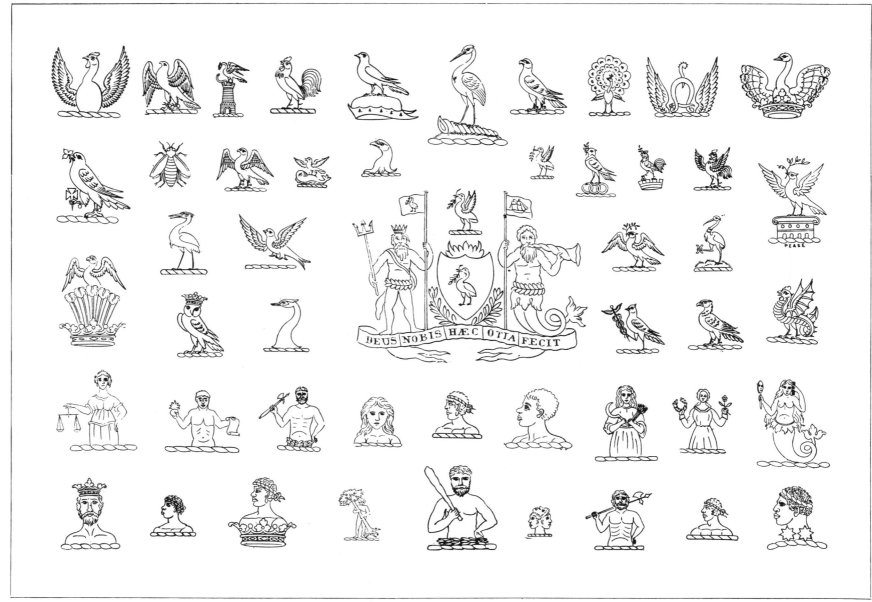

DEUS NOBIS HÆC OTIA FECIT

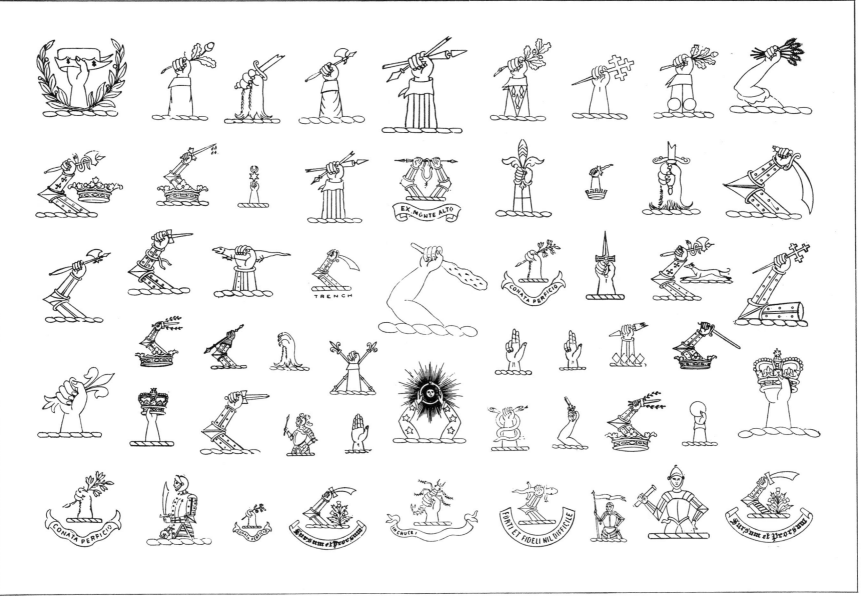

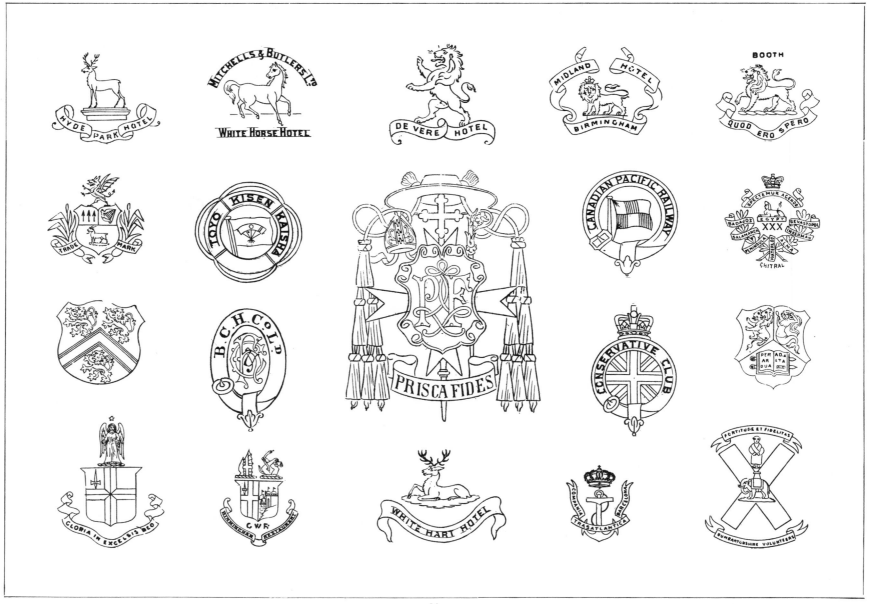

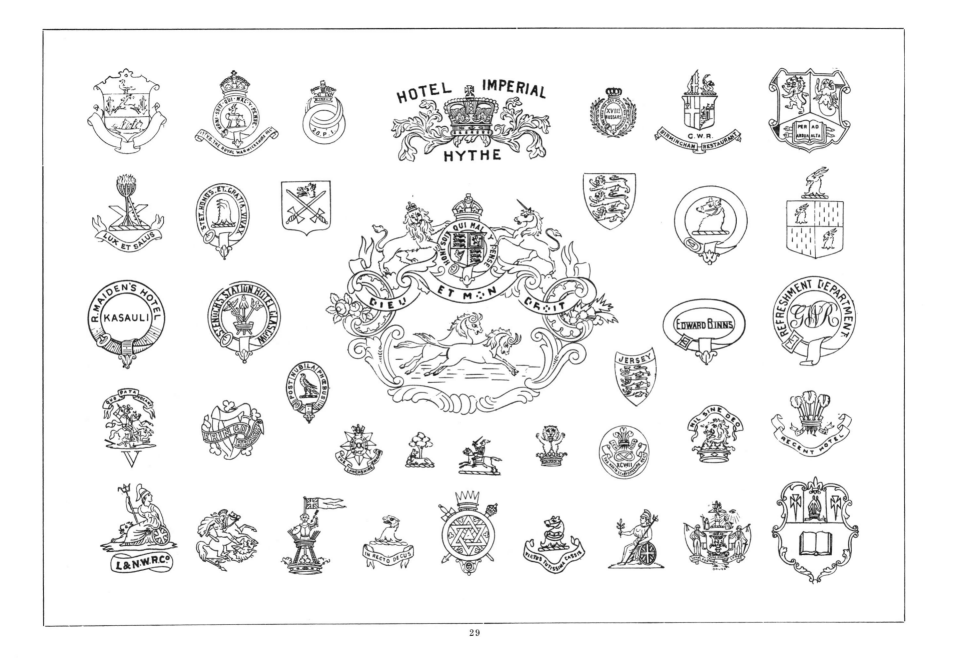

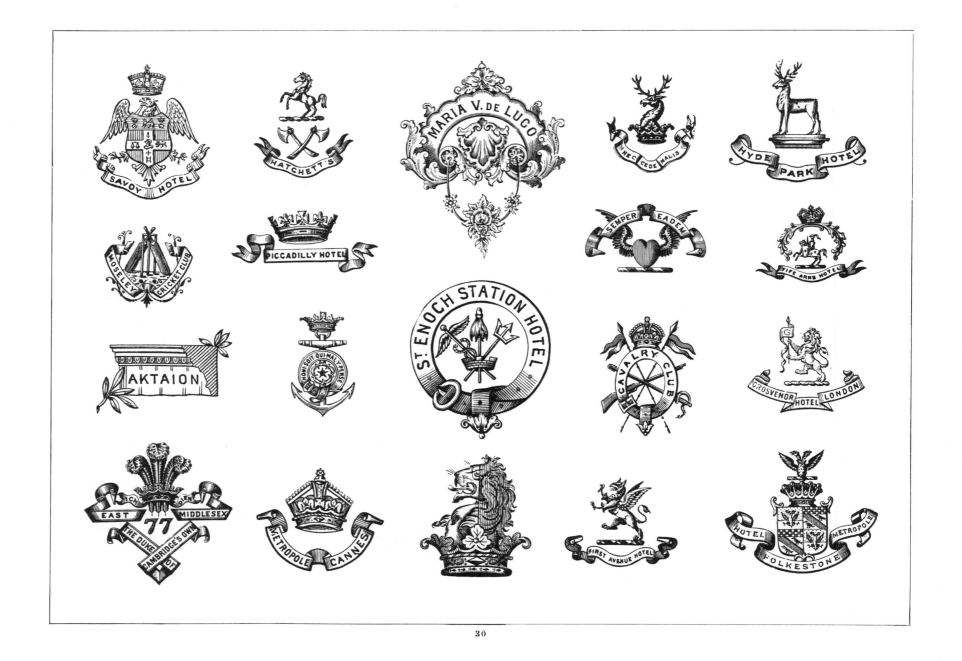

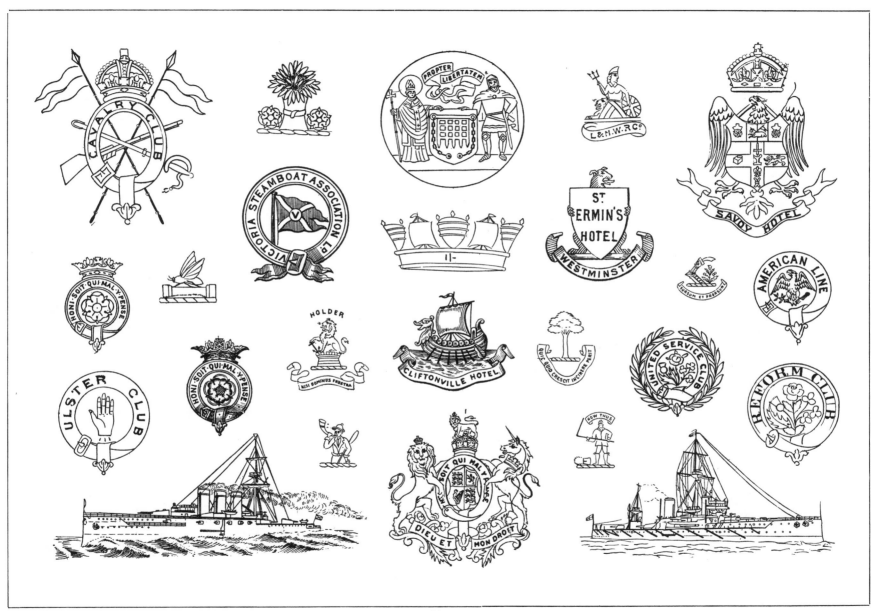

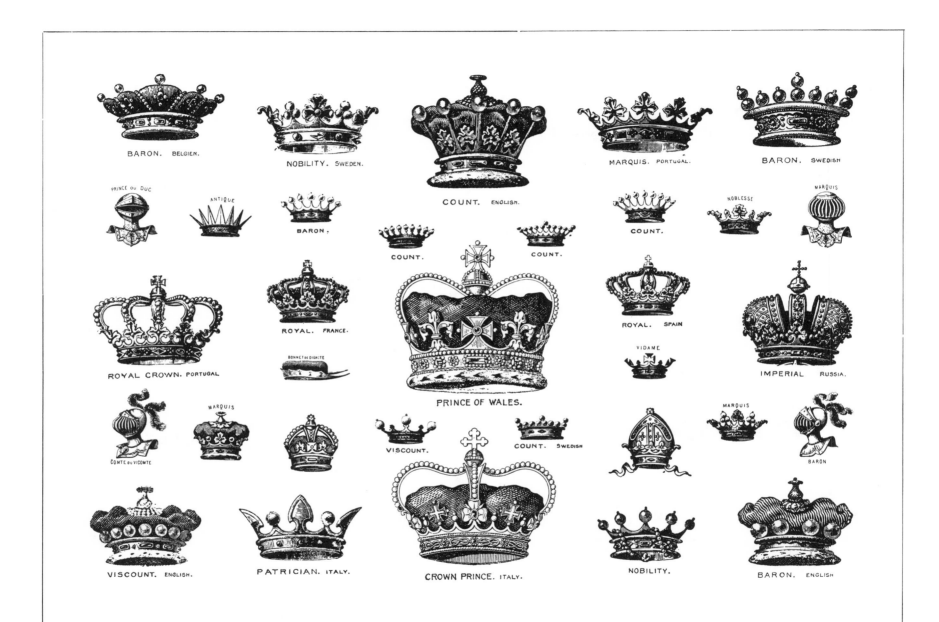

BARON. BELGIEN.

NOBILITY. SWEDEN.

COUNT. ENGLISH.

MARQUIS. PORTUGAL.

BARON. SWEDISH

PRINCE OU DUC

ANTIQUE

BARON.

COUNT.

NOBLESSE

MARQUIS

COUNT.

COUNT.

ROYAL. FRANCE.

ROYAL. SPAIN

ROYAL CROWN. PORTUGAL

BONNET DE DIGNITE

PRINCE OF WALES.

VIDAME

IMPERIAL RUSSIA.

COMTE OU VICOMTE

MARQUIS

VISCOUNT.

COUNT. SWEDISH

MARQUIS

BARON

VISCOUNT. ENGLISH.

PATRICIAN. ITALY.

CROWN PRINCE. ITALY.

NOBILITY.

BARON. ENGLISH

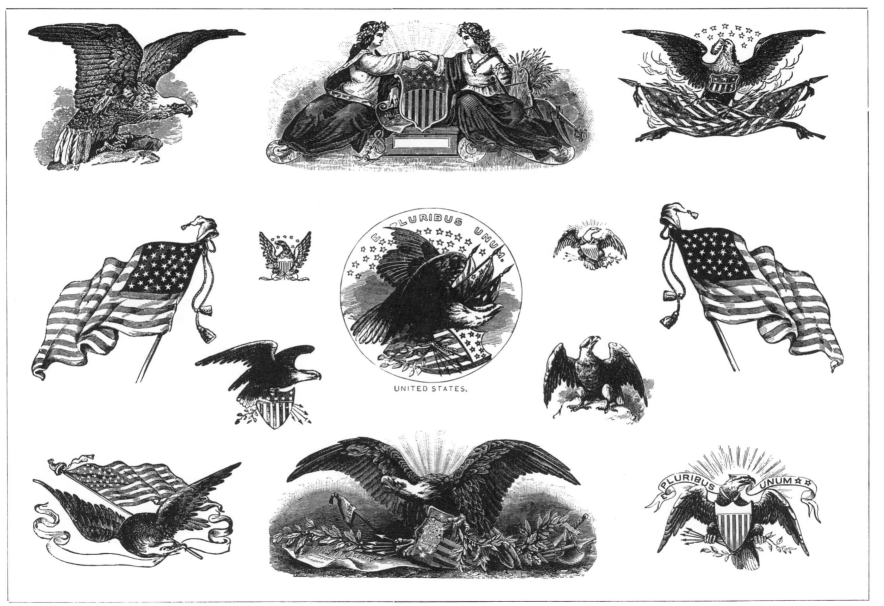

UNITED STATES.

33

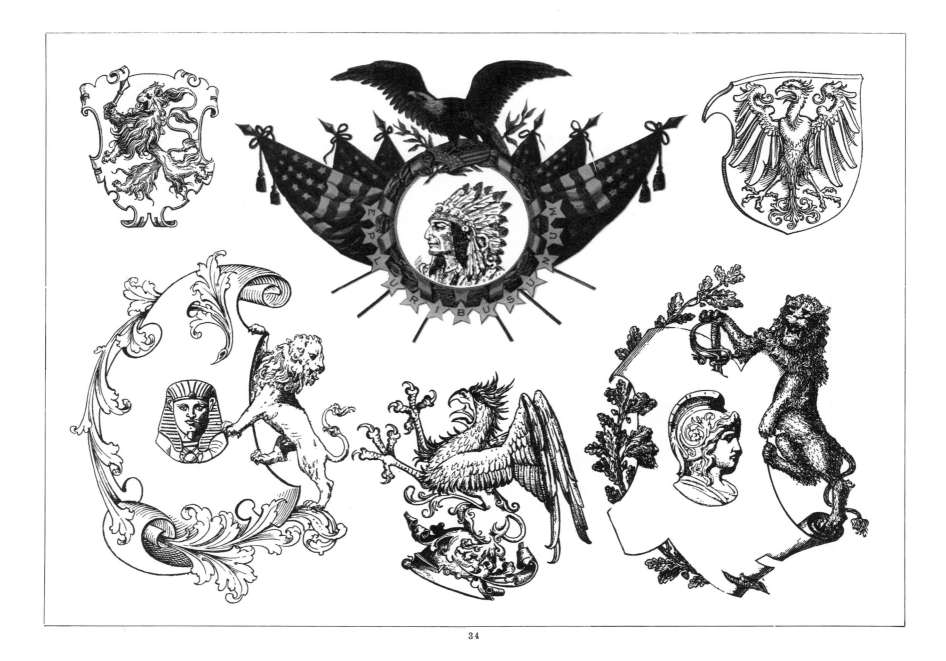

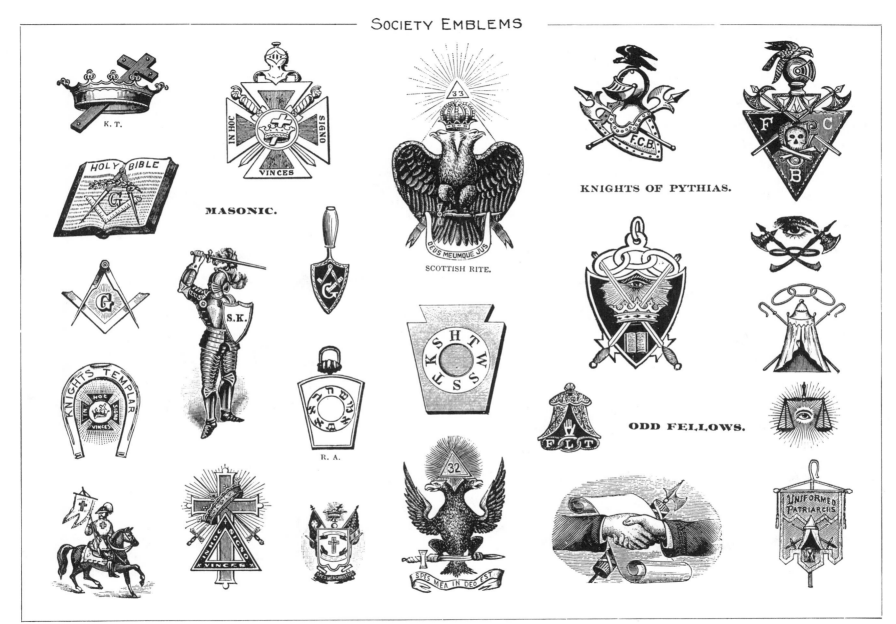

K. T.

HOLY BIBLE

IN HOC SIGNO VINCES

MASONIC.

SCOTTISH RITE.

DEUS MEUMQUE JUS

KNIGHTS OF PYTHIAS.

F.C.B.

F C B

G

S. K.

R. A.

KNIGHTS TEMPLAR

IN HOC SIGNO VINCES

K S H T W S S T

ODD FELLOWS.

F L T

IN HOC SIGNO VINCES

SPES MEA CHRISTUS

SPES MEA IN DEO EST

UNIFORMED PATRIARCHS

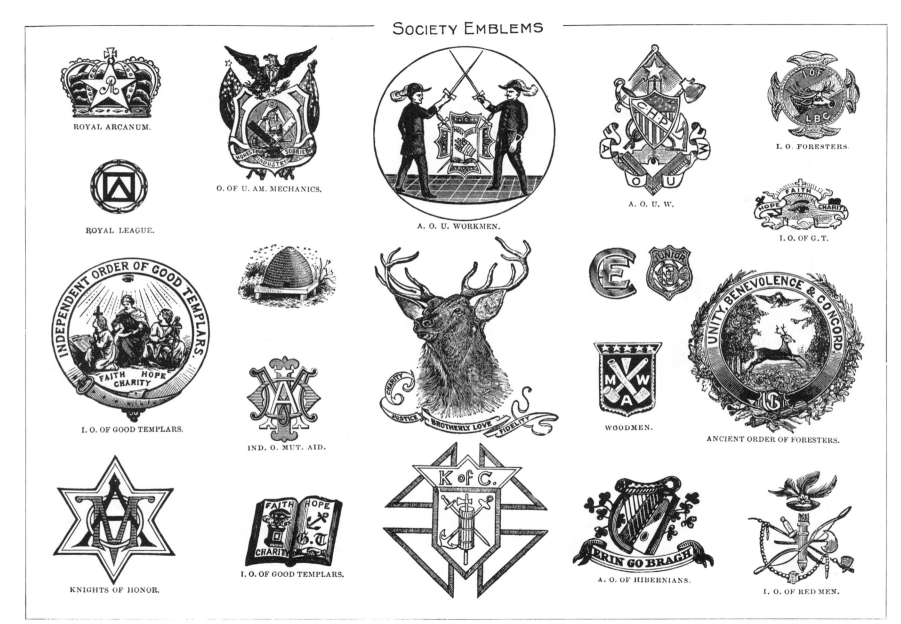

ROYAL ARCANUM.

ROYAL LEAGUE.

O. OF U. AM. MECHANICS.

A. O. U. WORKMEN.

A. O. U. W.

I. O. FORESTERS.

I. O. OF G. T.

I. O. OF GOOD TEMPLARS.

IND. O. MUT. AID.

WOODMEN.

ANCIENT ORDER OF FORESTERS.

KNIGHTS OF HONOR.

I. O. OF GOOD TEMPLARS.

A. O. OF HIBERNIANS.

I. O. OF RED MEN.

[Cuba Libre]

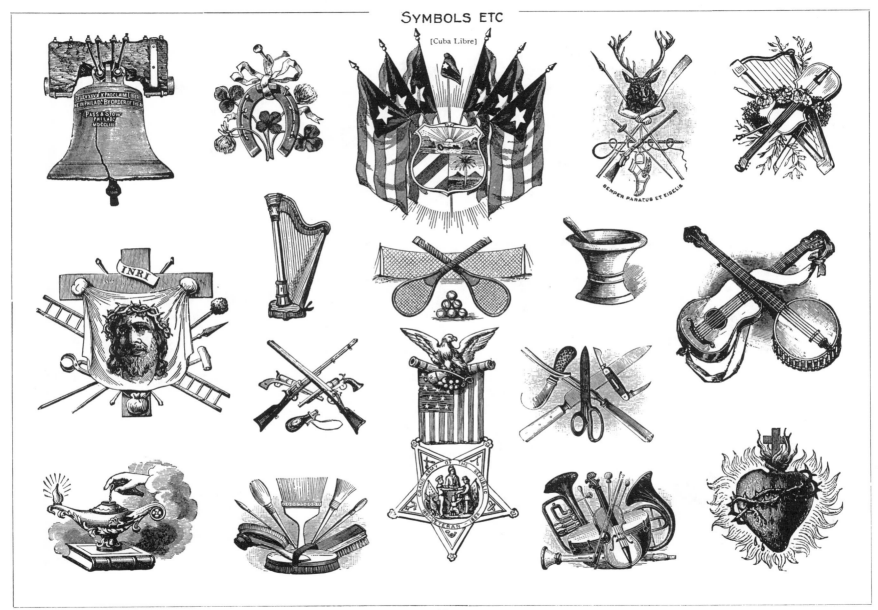

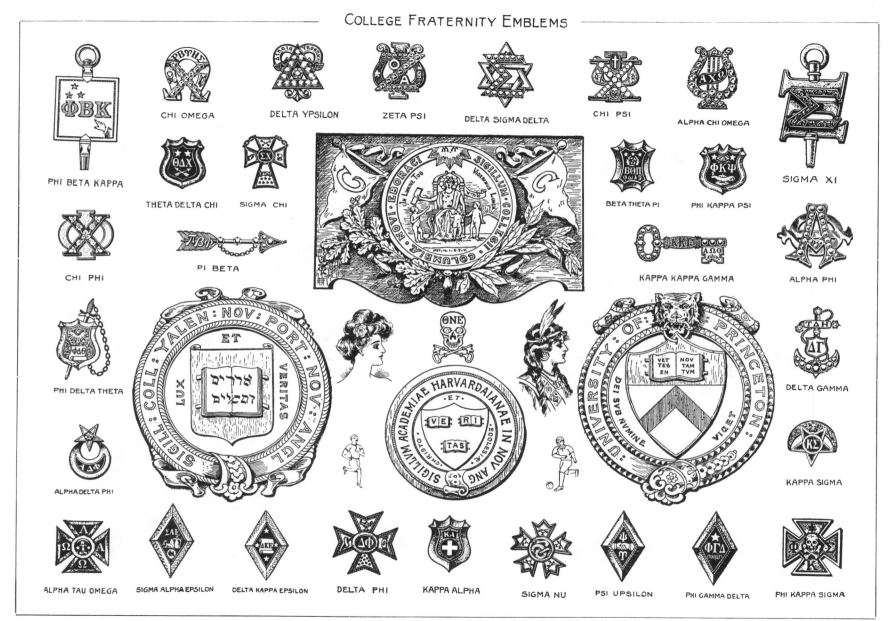

PHI BETA KAPPA

CHI OMEGA

DELTA YPSILON

ZETA PSI

DELTA SIGMA DELTA

CHI PSI

ALPHA CHI OMEGA

SIGMA XI

THETA DELTA CHI

SIGMA CHI

BETA THETA PI

PHI KAPPA PSI

CHI PHI

PI BETA

KAPPA KAPPA GAMMA

ALPHA PHI

PHI DELTA THETA

DELTA GAMMA

ALPHA DELTA PHI

KAPPA SIGMA

ALPHA TAU OMEGA

SIGMA ALPHA EPSILON

DELTA KAPPA EPSILON

DELTA PHI

KAPPA ALPHA

SIGMA NU

PSI UPSILON

PHI GAMMA DELTA

PHI KAPPA SIGMA

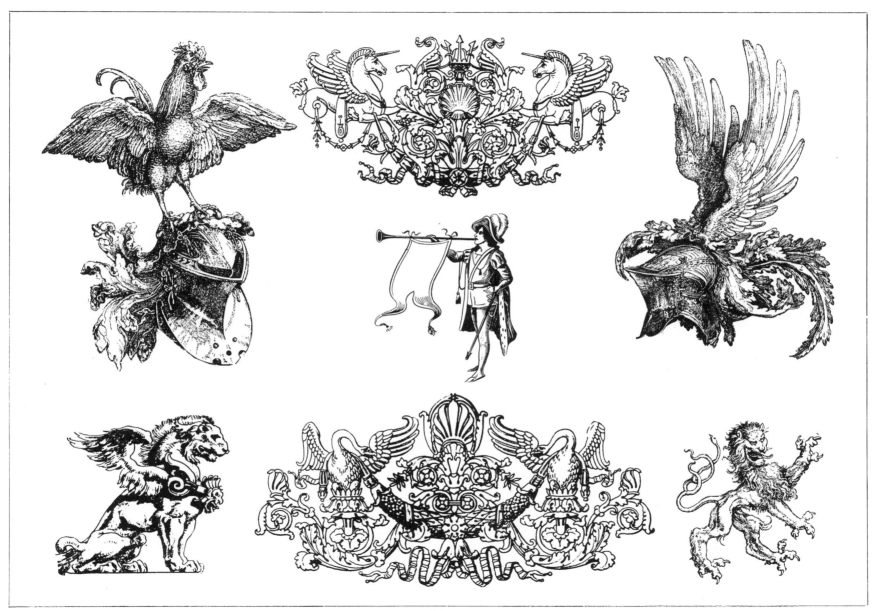

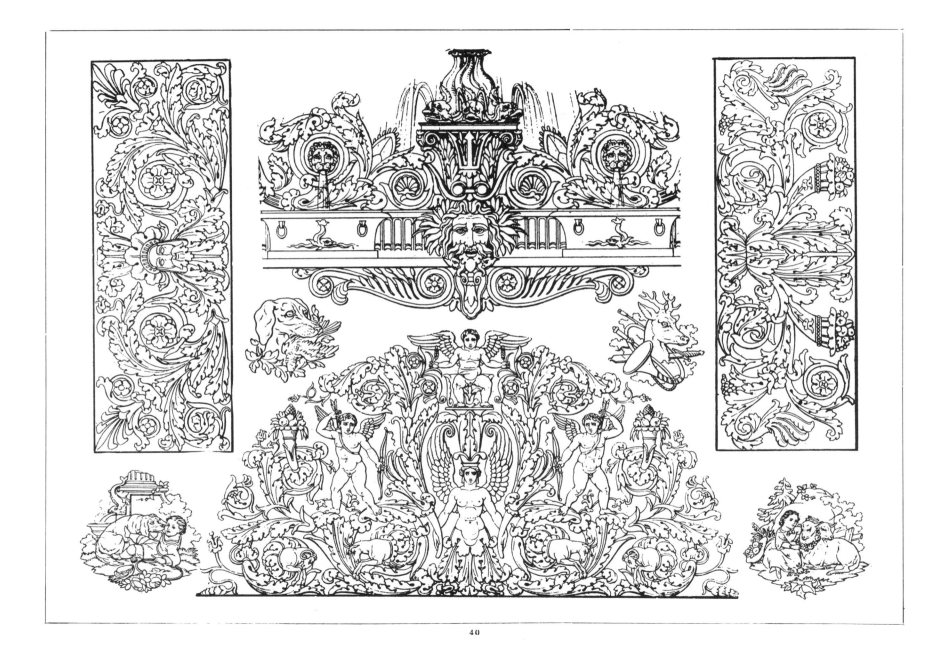

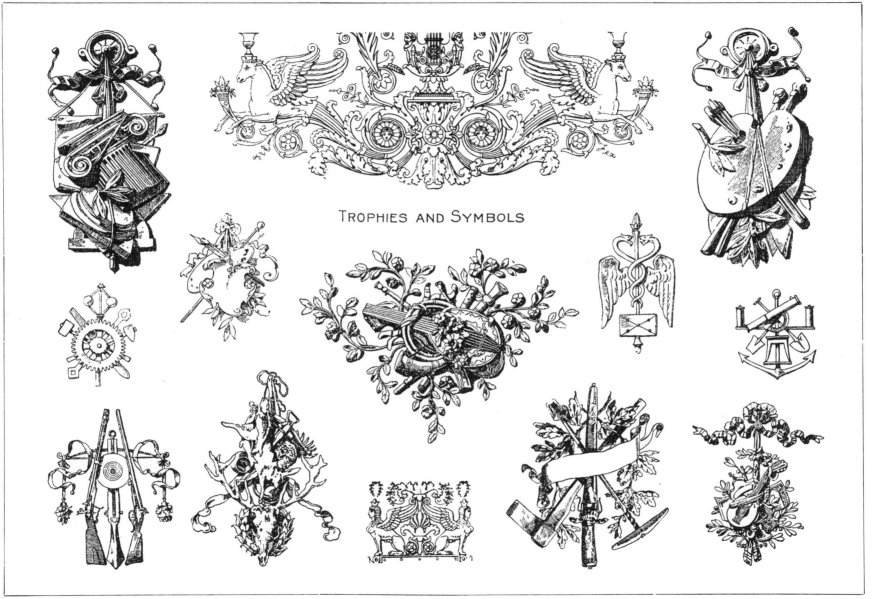

TROPHIES AND SYMBOLS

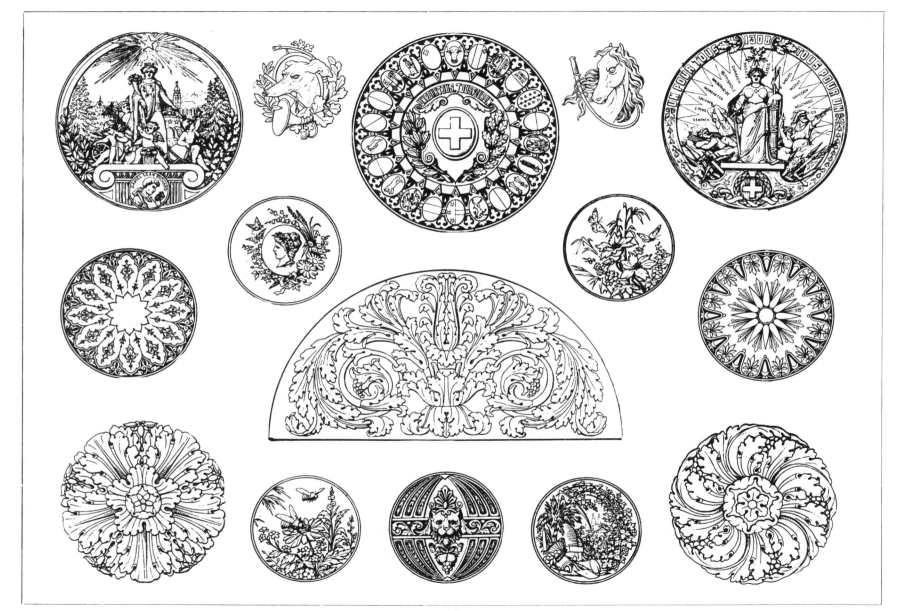

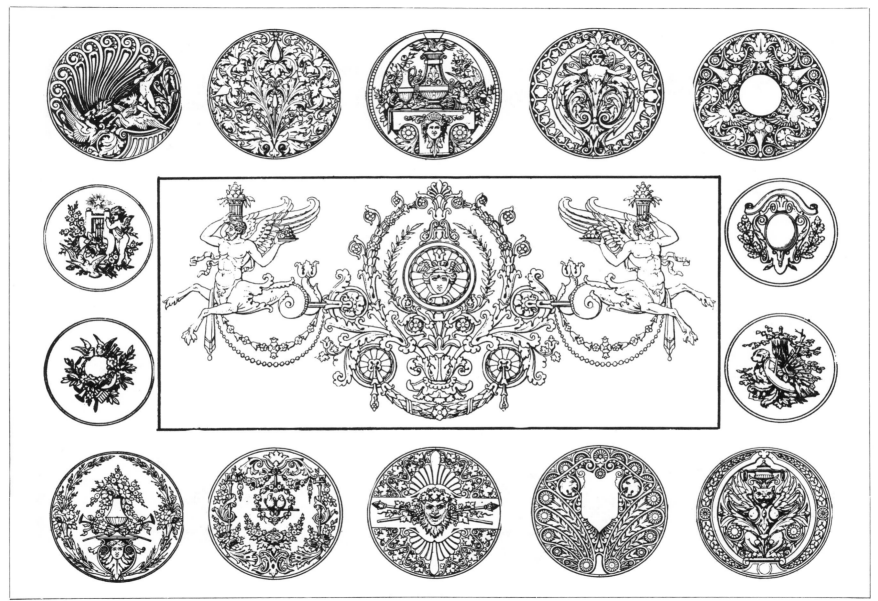

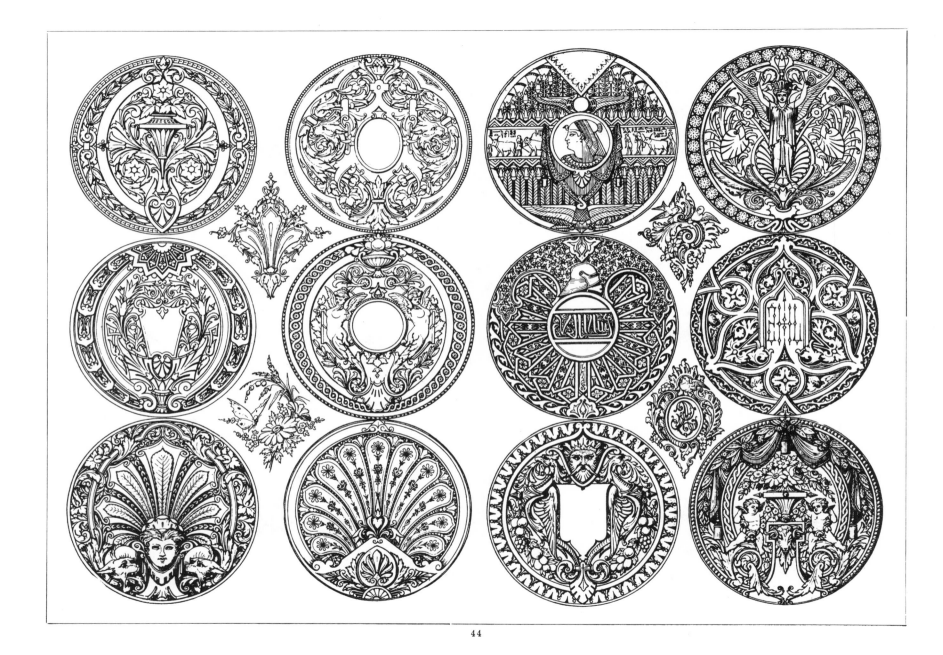

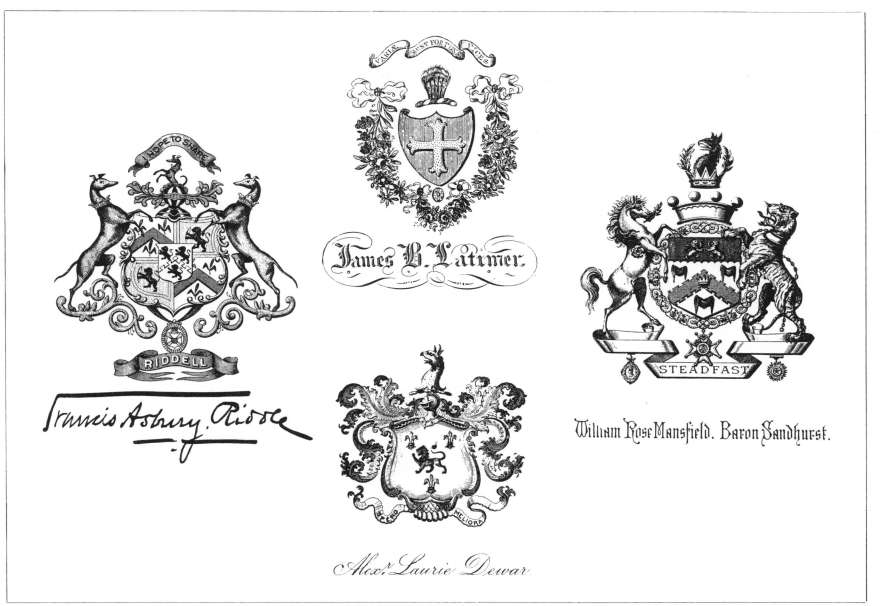

I HOPE TO SHARE

RIDDELL

Francis Asbury Riddle

VARIÆ · SUNT · FORTUNÆ · VICES

James B. Latimer.

SPERO MELIORA

Alex.ʳ Laurie Dewar

STEADFAST

William Rose Mansfield. Baron Sandhurst.

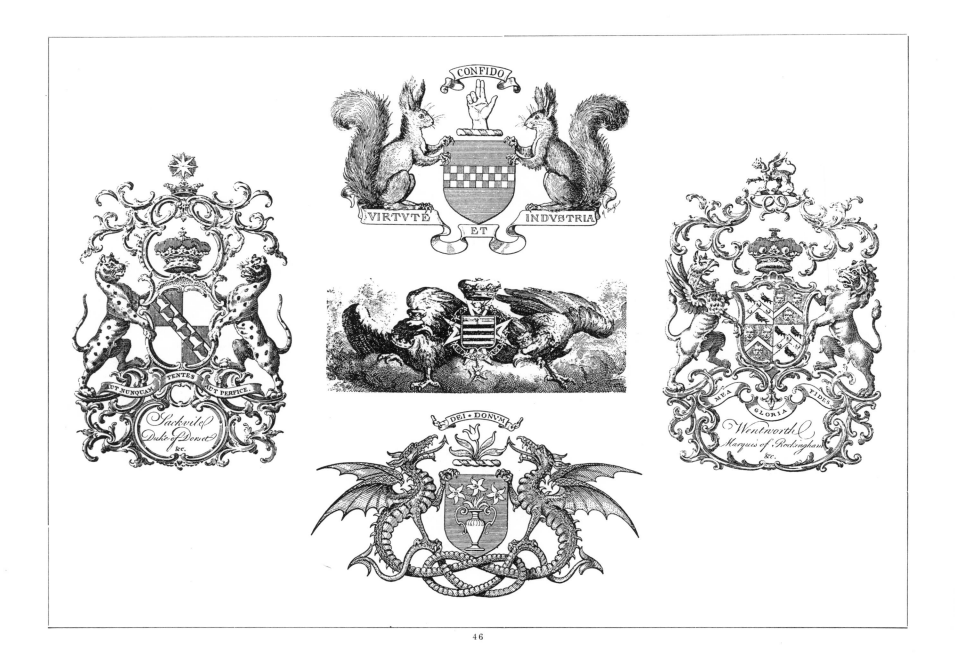

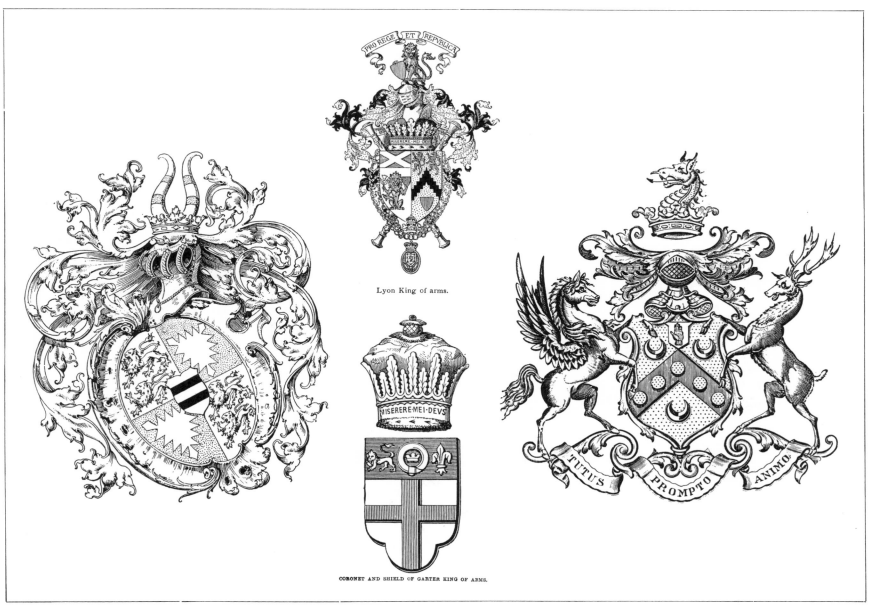

PRO REGE ET REPVBLICA

MISERERE·MEI·DEVS

Lyon King of arms.

MISERERE·MEI·DEVS

CORONET AND SHIELD OF GARTER KING OF ARMS.

TUTUS PROMPTO ANIMO

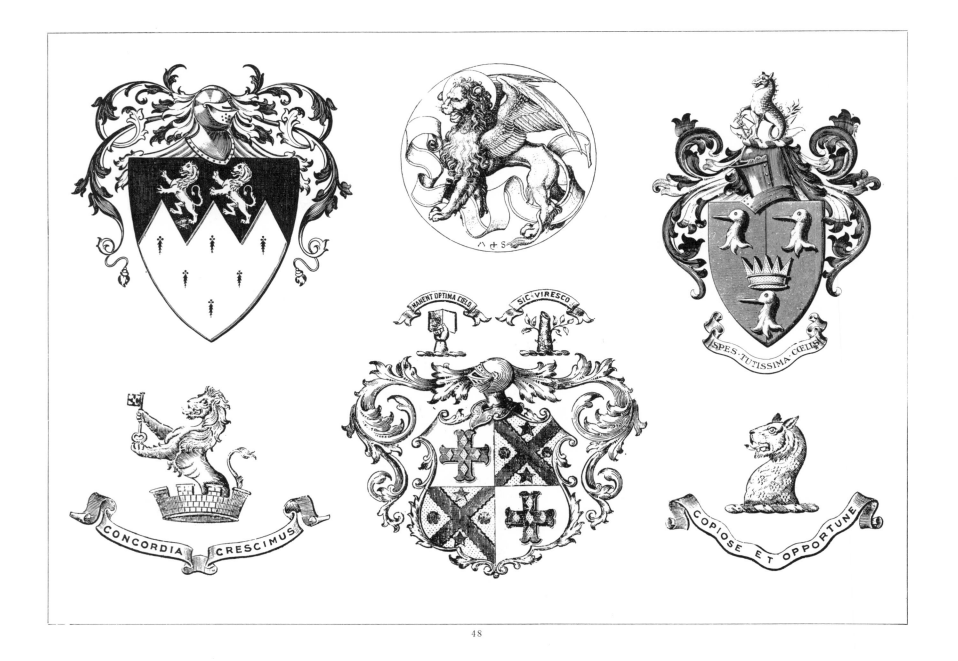

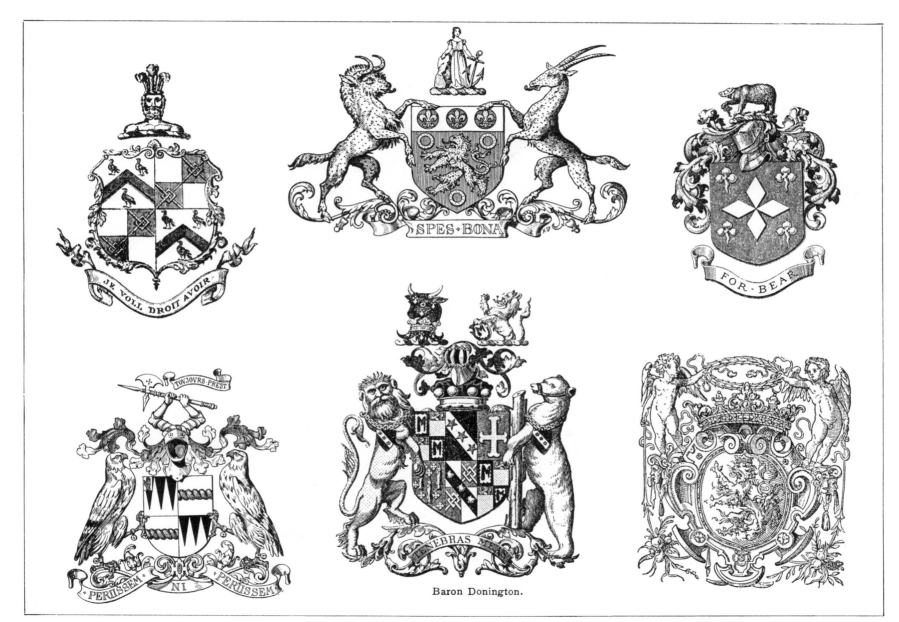

JE VOLL DROIT AVOIR

SPES·BONA

FOR·BEAR

TOVJOVRS·PREST

·PERIISSEM· NI ·PERIISSEM·

Baron Donington.

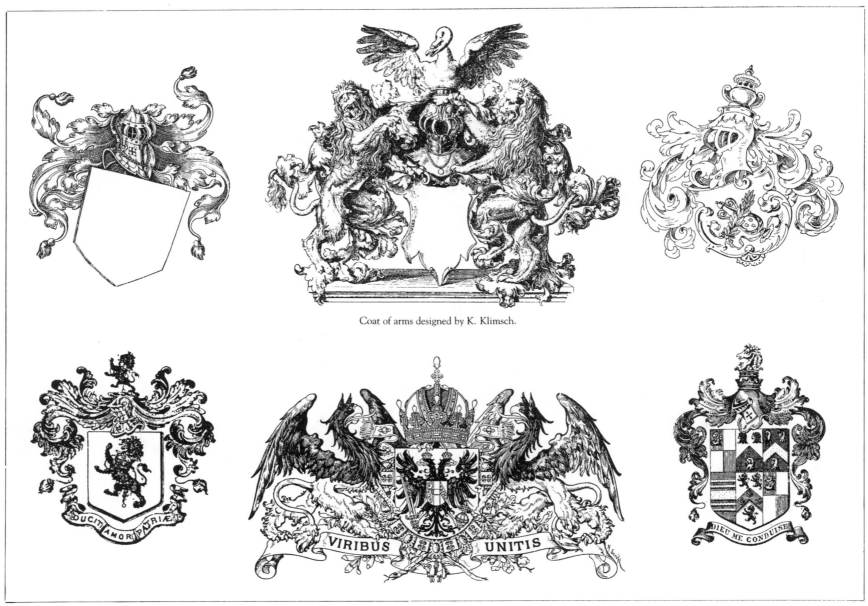

Coat of arms designed by K. Klimsch.

DUCIT AMOR PATRIÆ

VIRIBUS UNITIS

DIEU ME CONDUISE

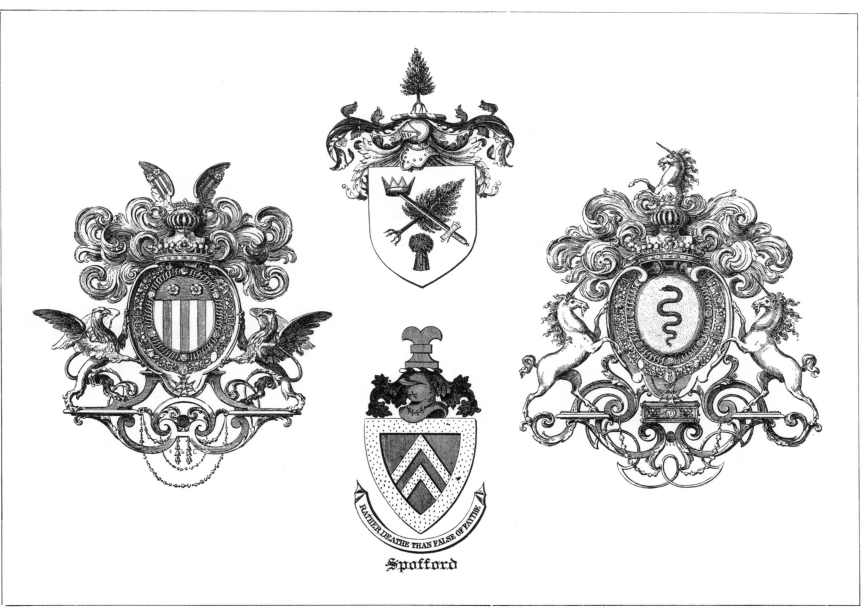

RATHER DEATHE THAN FALSE OF FAYTHE

Spofford

51

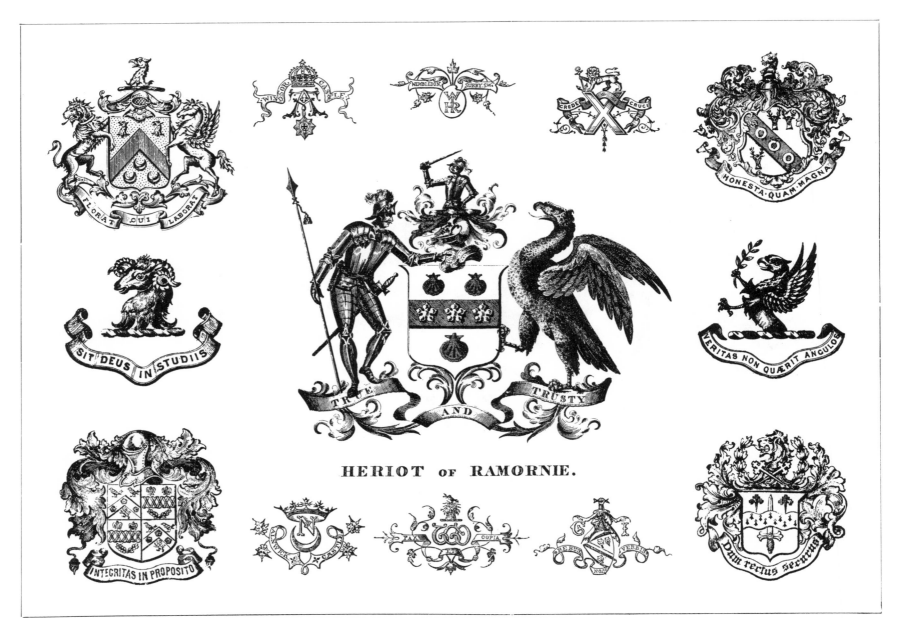

FLORAT QUI LABORAT

SIT DEUS IN STUDIIS

INTEGRITAS IN PROPOSITO

HONESTA QUAM MAGNA

VERITAS NON QUÆRIT ANGULOS

Dum rectus securus

CREDE CRUCI

TRUE AND TRUSTY

HERIOT of RAMORNIE.

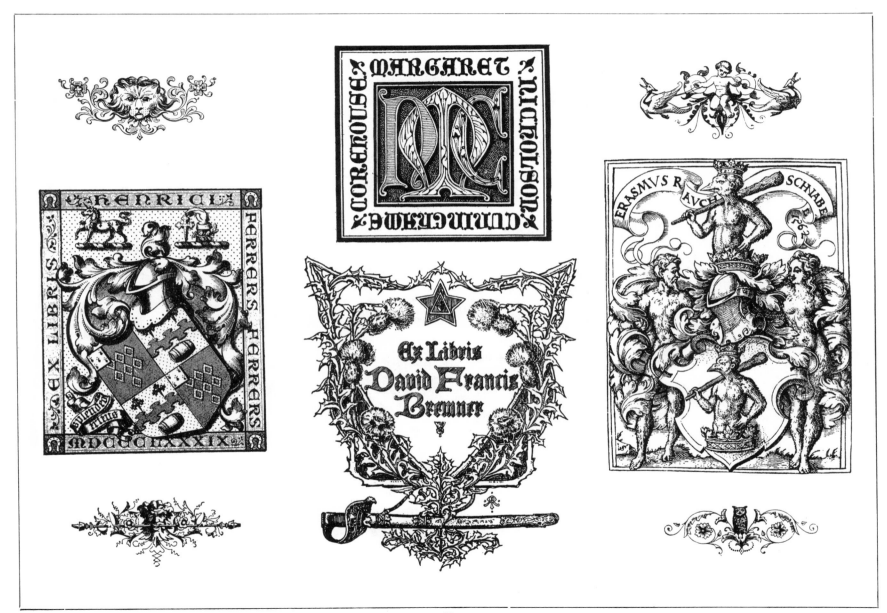

HILLMER

LUCIUS CHARLES COLMAN

EX LIBRIS

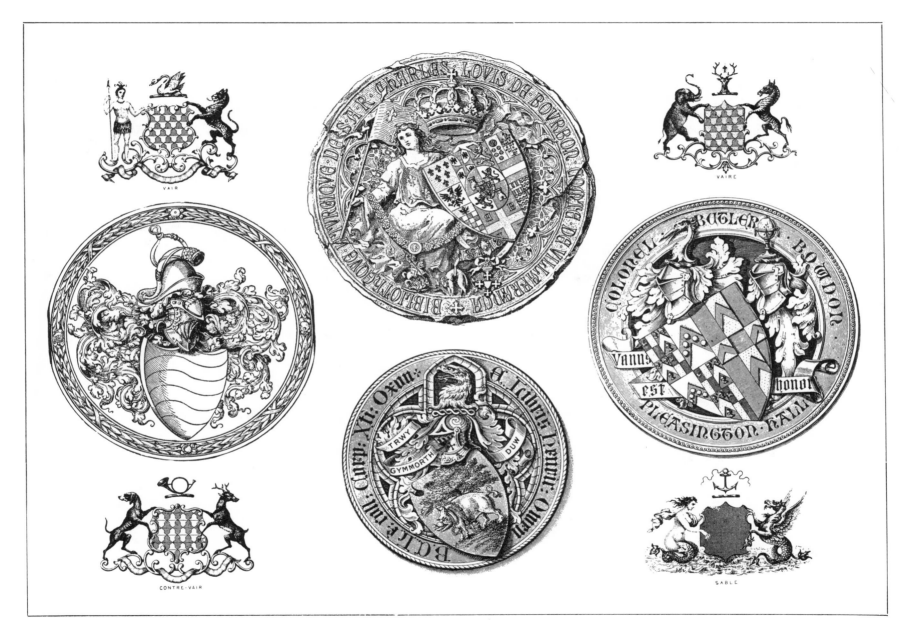

VAIR

VAIRÉ

CONTRE-VAIR

SABLE

55

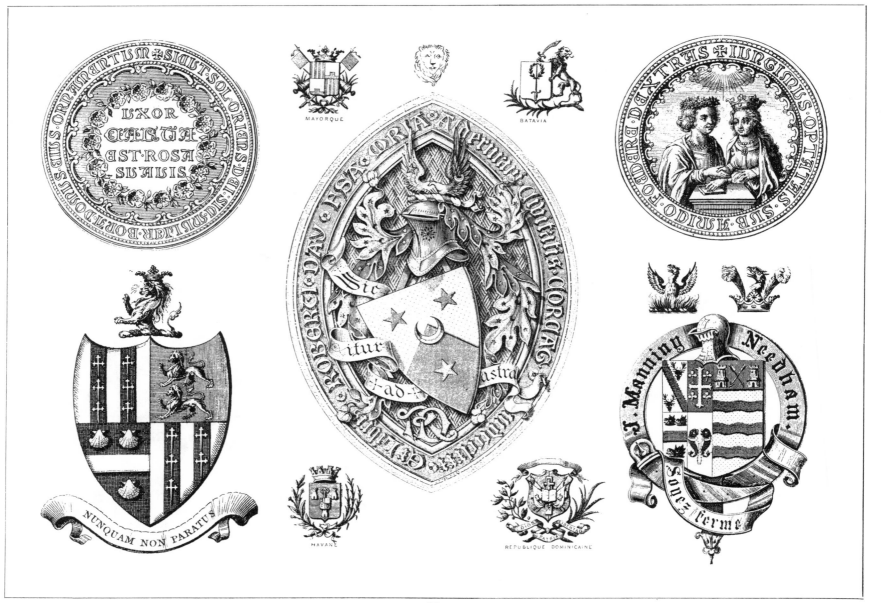

UXOR
CHASTA
EST ROSA
SUAVIS

MAYORQUE

BATAVIA

NUNQUAM NON PARATUS

HAVANE

REPUBLIQUE DOMINICAINE

J. Manning Needham.

Sovez ferme

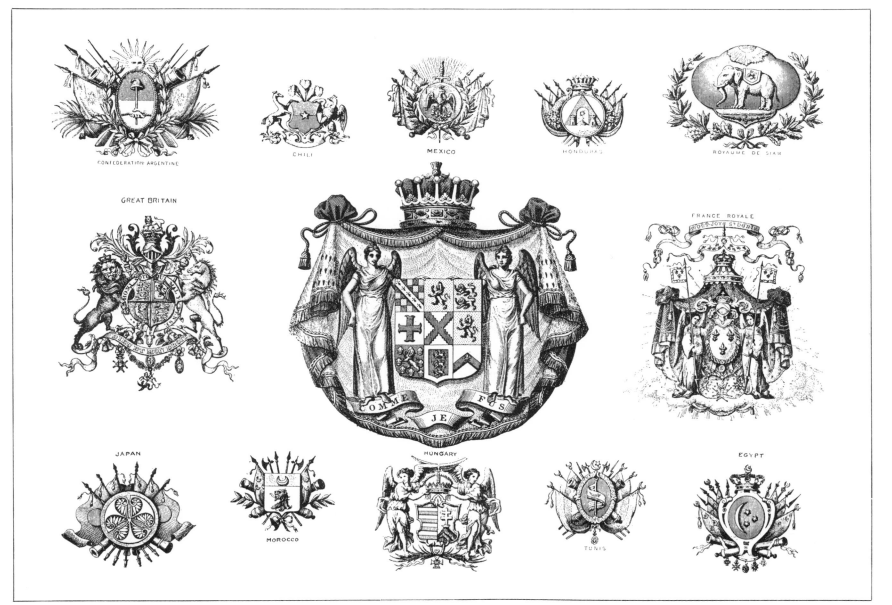

CONFEDERATION ARGENTINE

CHILI

MEXICO

HONDURAS

ROYAUME DE SIAM

GREAT BRITAIN

FRANCE ROYALE

JAPAN

MOROCCO

HUNGARY

TUNIS

EGYPT

57

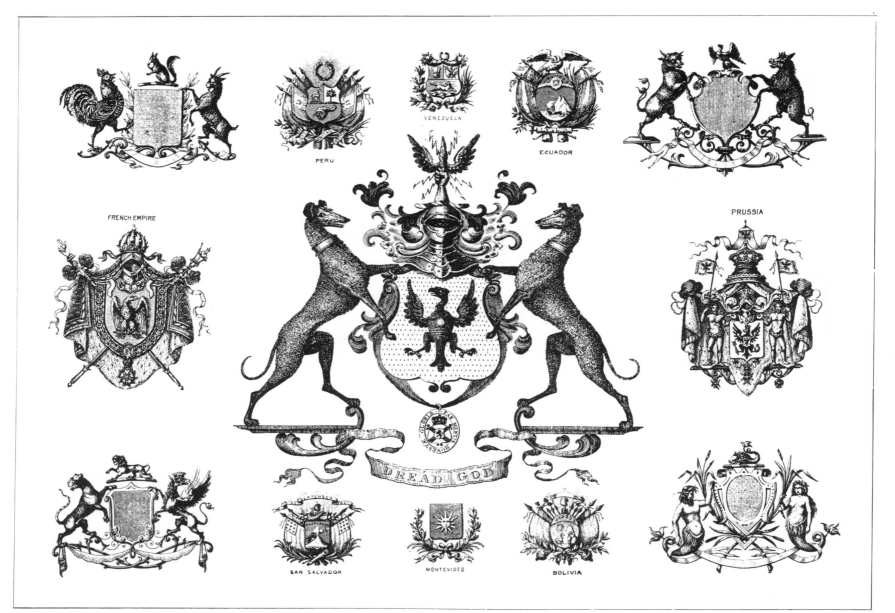

VENEZUELA

PERU

E-CUADOR

FRENCH EMPIRE

PRUSSIA

DREAD GOD

SAN SALVADOR

MONTEVIDEO

BOLIVIA

58

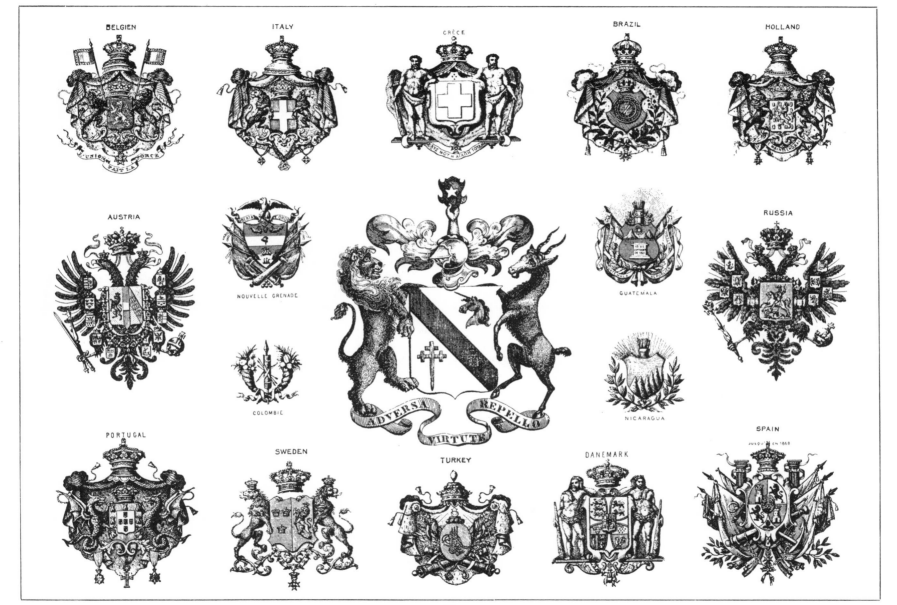

BELGIEN

ITALY

GRÈCE

BRAZIL

HOLLAND

AUSTRIA

NOUVELLE GRENADE

COLOMBIE

GUATEMALA

RUSSIA

NICARAGUA

PORTUGAL

SWEDEN

TURKEY

DANEMARK

SPAIN

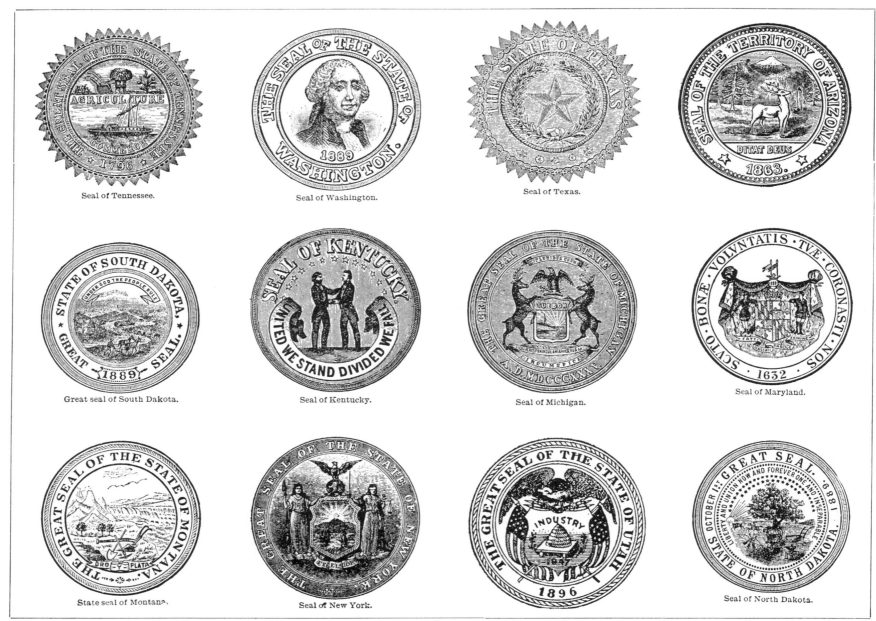

Seal of Tennessee.

Seal of Washington.

Seal of Texas.

Great seal of South Dakota.

Seal of Kentucky.

Seal of Michigan.

Seal of Maryland.

State seal of Montana.

Seal of New York.

Seal of North Dakota.

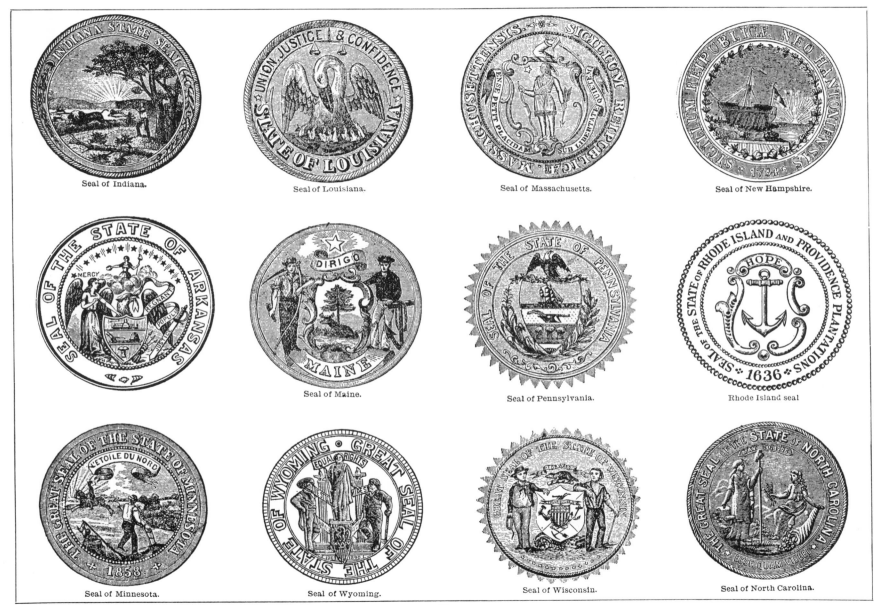

Seal of Indiana.

Seal of Louisiana.

Seal of Massachusetts.

Seal of New Hampshire.

Seal of Maine.

Seal of Pennsylvania.

Rhode Island seal

Seal of Minnesota.

Seal of Wyoming.

Seal of Wisconsin.

Seal of North Carolina.

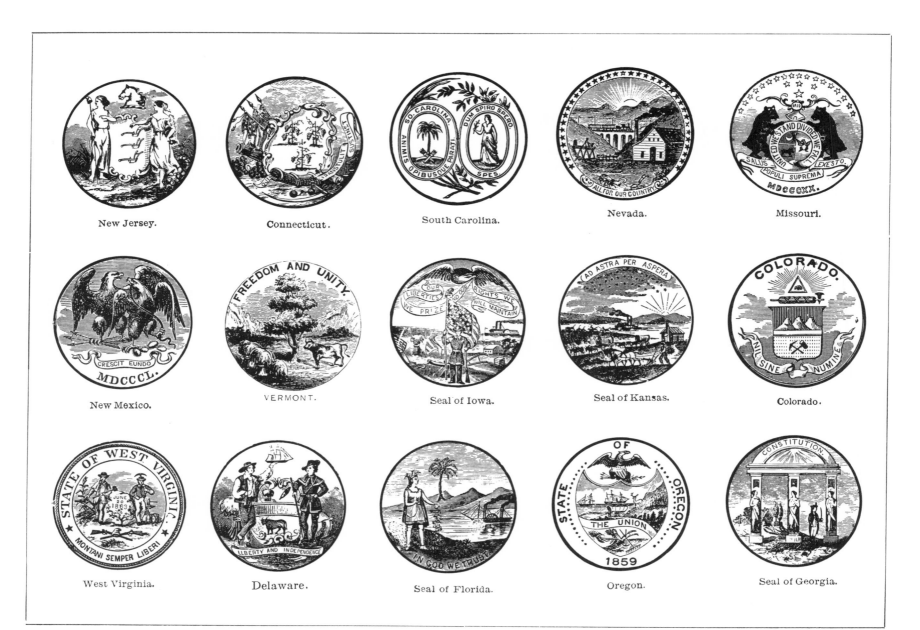

New Jersey.

Connecticut.

South Carolina.

Nevada.

Missouri.

New Mexico.

VERMONT.

Seal of Iowa.

Seal of Kansas.

Colorado.

West Virginia.

Delaware.

Seal of Florida.

Oregon.

Seal of Georgia.

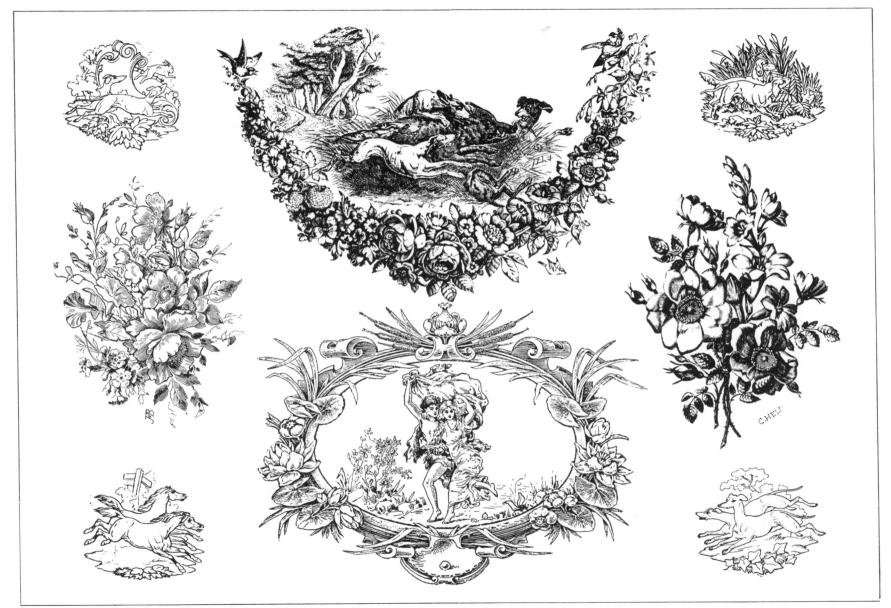

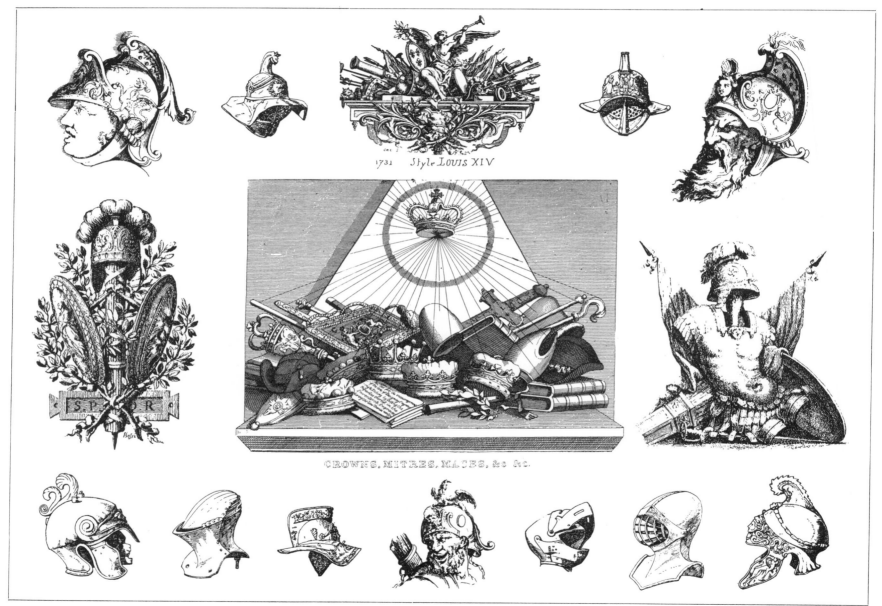

1731 Style LOUIS XIV

CROWNS, MITRES, MACES, &c &c.

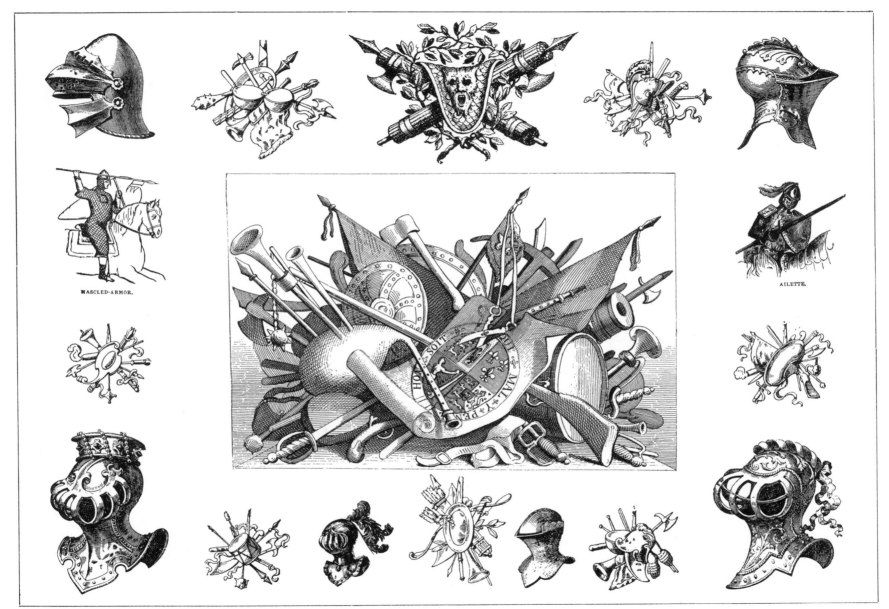

MASCLED-ARMOR.

AILETTE.

MODERN GERMAN GOTHIC

ABCDEFGHIKM
NOPQRSTUUW
abcde XYZ fghikl
mnoprsqtuvwxyz

FRENCH CURSIV

ABCDEFGH
IJKLMNOPQ
RSTTUVWXY

MODERN FRENCH

ABCDEFGHIJKL
MNOPQRSTUW
VXYZ
123456789 &

CHURCH TEXT

ABCDEFGH
IJKLMNOP
QRSTUVW
XYZ

OLD ENGLISH

A few of the most
useful and
Pleasing Alphabets
seen in
Heraldic
and other
Art Designs.
Etc.

GERMAN GOTHIC

ABCDEFGHI
KLMNOPQR
STUVWXYZ
abcdefghiklm
nopqrstuvw
xyz

GERMAN UNCIAL 5

ABCDEFGHI
JKLMNOPQR
STUVWXYZ
GERMAN 14th Cent.

FRENCH SCRIPT

ABCDEFGH
JKLMNOPQS
RTTUVWXY

MODERN ROMAN

ABCDEFGHIJKLM
NOPQRSTUVW
abcdef XYZ ghijklm
nopqrstuvxwzy

66

WHAT IS HERALDRY?

OR,

AN ENQUIRY INTO THE ORIGIN AND NATURE OF ARMORIAL ENSIGNS

IN CONNEXION WITH

HISTORY, BIOGRAPHY, POETRY, AND THE ARTS.

BY J. M. BERGLING.

UNDER this title it is not intended to write a formal treatise on heraldry, with all its details and technicalities; of such learned works there is a sufficient number already extant, expressly and only fitted for those who mean to make it the business and profession of their lives. But are there not a large number of persons in every possible branch of Art and manufacture, ornamental and decorative, who have constant occasion for some heraldic badges, devices or symbols, in various portions of their works, and to whom a little more correct idea of the real nature of such symbols, and how they should be treated, would be a benefit—inasmuch as it would give consistency where it is now very frequently wanting, and thus improve the style and raise the tone of their works; besides another very large class of intelligent general readers, who, not wishing to dive into all the intricacies of the subject as professed antiquaries or archæologists, yet would always be interested in seeing the correct meaning of many hundreds of passages and allusions in our historians, poets, &c? For this purpose it is proposed to embody, in a few pages the substance of a course of lectures, which have been delivered at many of the principal literary and mechanics' Institutions.

We will not now pause to dispute with the learned the relative antiquity of heraldic ensigns; some maintaining that they are as old as civilisation itself; others can see the origin of family distinctions in the phonetic alphabets of ancient India and China; some have found its origin in the lofty national banners and the double shields, titular and patronymic, of the ancient Egyptians; some, again, in the crests and cognominal ovals, since discovered in the sculptures of ancient Mexico; not a few, again, have seen in the emblematical standards of Nineveh a remarkable agreement with the symbols used by Daniel, Ezekiel, and the Apocalypse, as the origin of symbolical distinctions, and have maintained the connexion, or even the identity of the standards of the twelve tribes of Israel, with the twelve signs of the zodiac. But all these opposite systems are not so hostile as they at first sight appear, if we only recollect for a moment that they are all parts of that great system of symbolical teaching, which prevailed among the nations of antiquity before the use of letters.

Those who say there was no heraldry before the time of the Crusades should state in what sense they apply the term. It is evident, if we reflect on the early stages of society, that as mankind increased from individuals to families, from families to tribes, and tribes spread into states, nations, empires, and as civilisation progressed, all the relationships and requirements of society would become more complex, and would induce a self-evident necessity for some mode of recognition, by which the head of a family, or the chief of a clan, might be readily distinguished from other leaders. Hence ensigns and landmarks; indispensable in time of peace for order and discipline, much more so in war, to distinguish friends from foes. This principle appears manifest in the early history of every nation. All the writers of remote antiquity give to their chief personages certain symbols. Diodorus Siculus ascribes to Jupiter a sceptre, to Hercules a lion, to Macedon a wolf, to the ancient Persians an archer; and we all know the Roman eagle, a term synonymous with Rome itself from B.C. 752, down to the fall of the empire. These allusions in the earliest writers, poetical and mythological as they may be, all testify to one great principle or fact, viz., that no nation has ever yet appeared on the page of history, nor has any poet ever conceived the idea of any tribe or state, which did not use symbolical distinctions of some sort; what those distinctions were, and in what way they were carried out, is another question which we shall consider subsequently; it is sufficient now to establish the universality of the principle, and of which we have a fine example in Holy Writ, (see the Book of Numbers, ch. ii.) When the oppressed Israelites were brought out of Egypt, and encamped in the wilderness, the first thing was to marshal them in order; the twelve tribes forming four grand divisions, each with three sub-divisions; thus, on the east, under the standard of Judah, were to be planted the tribes of Judah, Issachar, and Zebulon; on the south side the standard of Reuben, and the tribes of Reuben, Simeon, and Gad; then the tabernacle in the midst of them; on the west the standard of Ephraim, and the tribes of Ephraim, Manasseh, and Benjamin; on the north side the standard of Dan, with the tribes of Dan, Asher, and Naphtali; "And thus every man of the children of Israel shall pitch by his own standard, with the ensigns of his father's house; far off about the tabernacle of the congregation shall they pitch." Now there can be no question that the ancient modes of distinction were very various; in some cases they would be standards carried aloft in the field, in others a device depicted on their tents, or dwellings, in some a mark on the costume, in others on the skin itself, as in tattooing, which strange to say is heraldry.

Cut of the PELTA Greek Shield, from Hope's "Costumes of the Ancients."

Having shown what heraldry is, we will now look at a few of its principal features, and the way in which they were principally carried out; the first and most obvious of which will be the shield and the banner.

For nearly four thousand years the shield has been a term synonymous with safety and defence; the first promise made to the Patriarch was, "Fear not, Abram, I am thy shield."

From the earliest accounts we have of the primitive Greek shields, it appears that the oval shield was invented by Prœtus, and the round shield by Acrisios of Argos, and was called by the Greeks the *aspis* or *sacos*, among the Latins the *clypeus*, and from the place of its origin, it was known as the Argolic buckler. There was a smaller round shield called the *parma*, and also the smaller oval shield called the *pelta*. But eventually, when the Roman rule and the Latin language became predominant, the general term *scutum* implied a shield of any kind, hence we have scutum for a shield, target, buckler or escutcheon, and from the same source we have *scutiger*, a page bearing his master's shield or buckler, in other words an esquire of arms. Hence certain divisions of the Roman foot were termed *scutarii*, armed with bucklers or targets, and a maker of shields was a *scutarius*.

It is necessary to remark here that it was not the practice of the great warriors of antiquity to carry their own shields, except when actually engaged in combat, at all other times the shield was borne by the scutiger or shield-bearer; see a good example in 1 Sam. xvii. When Goliath, the Giant of the Philistines, came out to challenge the armies of Israel, "one bearing a shield went before him." The office of shield-bearer was esteemed a post of considerable honour, as the immediate personal attendant on the great captain.

AMAZON'S SHIELD. CENÆUS' SHIELD.
From the Phygalian Sculptures.

WARRIOR'S SHIELD, from an Etruscan Vase.

After the shield, the most important feature in Heraldry is the banner. By a banner we understand a piece of drapery, or other object, elevated on a pole, and carried aloft in the battle-field, and either with or without a device upon it; and all the various terms of Flag, Standard, Banner, Colour, Ensign, Pendant, Streamer, Banneroll, Pennon, Pennoncell, &c., are only technical variations of the same thing. But the general terms, Banner, Standard, and Ensign, comprise all that belongs to the subject in History, or Scripture, or Poetry.

Banners have been in use from the earliest ages. Xenophon gives us the Persian standard as a golden eagle, mounted on a pole or a spear; and the well known eagle of Rome has been already noticed. We find banners very early in use among the nations of Europe.

When Constantine the Great was on the eve of a battle with Maxentius, we are told that a luminous standard appeared to him in the sky with a cross upon it, and this inscription :—*In hoc signo vinces*, By this sign you shall conquer; and that this so encouraged Constantine and his soldiers, that they gained the next day a great victory.

When Waldemar II. of Denmark was engaged in a great battle with the Livonians in the year 1219, it is said a sacred banner fell from heaven into the midst of his army, and so revived the courage of his troops, that they gained a complete victory over the Livonians: and in memory of the event, Waldemar instituted an order of knighthood called " St. Danebrog," or the strength of the Danes, and which is still the principal order of knighthood in Denmark. Now, taking these legends for as much as they are worth, and no more; what do they prove? Not that this miraculous standard and cross came to the assistance of Constantine; not that this miraculous banner came to the aid of Waldemar; but they prove that such was the paramount importance attached to the sacred banner among the forces, that wherever it was present, it was a great means of inspiriting the men with increased confidence and courage, and so contributed to the victory.

The great importance attached to the banner in the middle ages is not to be wondered at, when we consider that it was a kind of connecting link between the military and the clergy; it was a religious symbol applied to a military purpose, and this was the feeling which animated the Crusaders and the Templars in their great struggle against the enemies of Christianity. The contest then was between the crescent and the cross—between Christ and Mahomet.

TEMPLARS' DEVICE.

While touching on the Crusades, let me notice another interesting fact. Every one who has taken any notice of heraldry, must have been struck with the extensive prevalence of crosses, in almost endless variety of form and colour,—indeed, so great is their diversity, that a complete description of all the crosses used in heraldry would suffice to fill a volume, and not a very small one. So striking a feature must have had a common origin; that origin was evidently the expeditions to the Holy Land. The very terms Croisades, Crusades, Crusaders, Soldiers of the Cross, all point to one centre for the extensive adoption of this symbol; and while the English fought under the red cross banner of St. George, the other nations and detachments adopted crosses of various forms and tinctures for distinction sake. This is beautifully embodied by Edmund Spencer in his "Faerie Queene," where he describes the red cross knight—

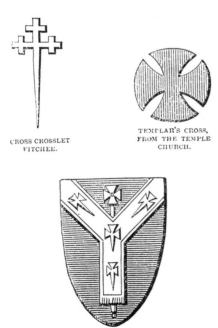

CROSS CROSSLET FITCHEE.

TEMPLAR'S CROSS, FROM THE TEMPLE CHURCH.

CROSSES PATTEE AND FITCHEE, SEE OF CANTERBURY.

In the war between the Houses of York and Lancaster, equally well known as the War of the Roses, because the House of Lancaster had a Red Rose for its badge, while the House of York bore a White Rose; they also bore several other badges, as the Falcon and Fetter-lock &c., but the chief ensign of the House of York was a White Rose, emblazoned on the middle of the Sun; thus we see the full beauty of that passage—

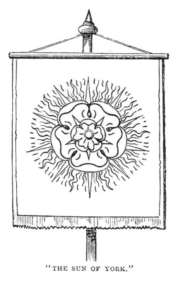

"THE SUN OF YORK."

"Now is the winter of our discontent
Made glorious summer by this sun of York,"

where Shakspere beautifully expresses the success of the Yorkists, by apostrophising their heraldic ensigns.

From the time of King Richard I., and downwards, when the monarch went himself into the battle-field, it was the custom to carry in his presence the King's banner, the three gold lions passant gardant on a crimson field. Now on the principle just named, when we became united with Scotland and Ireland, the royal ensign of England was quartered with the royal arms of Scotland and of Ireland, as

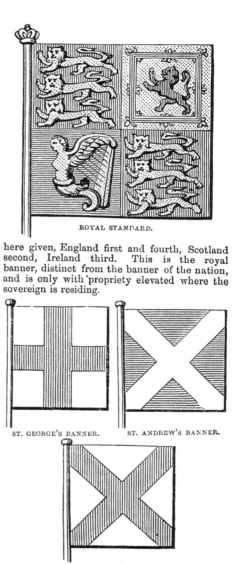

ROYAL STANDARD.

here given, England first and fourth, Scotland second, Ireland third. This is the royal banner, distinct from the banner of the nation, and is only with propriety elevated where the sovereign is residing.

ST. GEORGE'S BANNER.　　　ST. ANDREW'S BANNER.

ST. PATRICK'S BANNER.

69

ANOTHER curious, and not uninstructive feature of heraldry, is the singular assimilation between arms and family names. These have been called "punning arms," on the supposition that the arms were made as a pun on the name, or the name upon the arms; but instead of punning, would it not be more correct to say that this is recurring to first principles? or, in other words, it is reverting back to the practice of the most remote antiquity, when the name of every person or

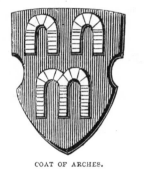

COAT OF ARCHES.

place had a symbolical meaning. The sacred writings are filled with such examples: from

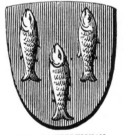

COAT OF HERRINGHAM.

Adam, red earth, Abram, high father, Abraham, father of a multitude, Jacob, heeler, or supplanter, Israel, a princely prevailer with God; and the same fact applies to the names of places. And in very early examples it is highly probable, as suggested in the case of Hengist and Horsa, that the name may have been taken from the banner or coat of arms. We have a great many examples in English heraldry; as Forrester, three bugle horns; Archer, three arrows; Heron, Aries, three

rams' heads; Leveson, three leaves; Hunter, three greyhounds and a bugle horn; Bannerman, already noticed; Grosvenor, and a great many others. Arches, an old Devonshire family, bears gules, three arches, two simple, one double. Herringham, an old Dorsetshire family, bears gules, three herrings: these coats are here given. The Hawkers of Essex, and of Wiltshire, bear sable a hawk standing on a perch,

COAT OF HAWKER.

After death of King Robert the Bruce, in 1329, Lord James Douglas carried the heart of his royal master to the Holy Land for interment, and in memory thereof the Douglases bear in their arms a crowned heart. But Lord Douglas was accompanied by Sir Simon Locard of Lee,

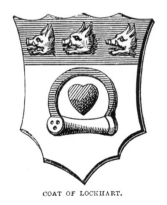

COAT OF LOCKHART.

Lanarkshire, who in memory of the same event, changed his name to Lockheart, and added to his arms a heart within a lock, and the motto, "Corda Serrata Pando,"—I lay open locked hearts.

The office of the herald is evidently one of great antiquity. It is alluded to in the Siege of Troy, where Homer in describing the Shield of Achilles, in book 18th, says

"The appointed heralds still the noisy bands,
And form a ring with sceptres in their hands."

The only instance, I believe, of a herald being mentioned in scripture history, is in Daniel, chap. iii., where he is brought out as proclaiming the will of Nebuchadnezzar, king of Babylon. Then a herald cried aloud, "To you it is commanded, to people, nations, and languages," &c. Verstegan and some other authors derive the title from Here and Hault, the champions of an army, whose special office it was to proclaim the challenges in the warlike field. But whatever may be the etymology, it is evident that the office, from the earliest periods of history, has been always substantially the same. In ancient times it was the duty of the herald to proclaim the will of the monarch, or of the chief commander, to conduct the negotiations between hostile or foreign powers, and to regulate all state ceremonies.

In former times many of the principal nobility had their own heralds, and their pursuivants of arms, to whom they granted proper coats, or some distinctive badges, and who attended their lords on all important occasions, as the king himself was attended by his heralds and other state officers.

The appointment of the different heralds originated with several of our earlier kings, and at different times. But they were first incorporated as a collegiate body, under the authority of the crown by King Richard III., who established them in an official residence, which they still hold in St. Bennett's Hill, near St. Paul's Cathedral, London, and they are styled "The corporation of kings, heralds, and pursuivants of arms," and are known to this day as the Heralds' College; but in all official documents their proper appellation is "The College of Arms."

The subject of family mottoes is a highly interesting one, and presents a rich variety of curious and diversified topics. What the motto originally was, does not appear a very difficult question, although a considerable amount of learning has been written upon the subject, but all scholars now tolerably well agree in pointing to one source for the origin of the motto in connexion with armorial ensigns, namely, that it originated with the war cry of the ancients. In the early history of almost every country, we find it to have been the custom at the outset of battle, for the general to give out some short and pithy expression, which was echoed through the ranks when they rushed upon the foe, and was supposed to answer two purposes, first to animate the courage and feelings of the combined forces, by attacking, all at the same instant, all with the same expression on their tongues, all, in fact, shouting out the same words, and to strike terror into the foe by this simultaneous shout. The very nature, then, of the war-cry, would seem to imply that it should be a short and expressive sentence, containing a meaning in few words, as anything like an elaborate speech would be evidently quite out of place on such an occasion. In fact, the subject of family mottoes might be not inaptly compared to the Book of Proverbs, where every sentence contains some valuable truth, complete in itself, and unconnected with any other matter. Camden calls the motto, "Inscriptio," the inscription; some writers have termed it the "Epigraphe," others again have given it the name of the "Dictum," or "Saying," and another proof that the war-cry gave rise to the motto is, that the French writers, to this day, call the motto the "cri;" and thus that which was the war-cry in ancient times, became afterwards, in the altered mode of warfare, a memorable expression or a favourite sentiment, attached to the shield of arms, and was thus handed down to their descendants, and became their family motto.

Although we have seen that the crest was brought more prominently into use by the tournaments, yet there are proofs that some of the crests borne by many of our ancient families have had their origin in the striking events of the olden times in which they lived. I only cite one as an example, out of many which could be given.

In the great struggle for the throne of Scotland, Robert the Bruce happened to meet the Red Comyn, in the Grey Friars' Church, at Dumfries, in the year 1340, and in a conference between them they came to such high words, that at last, in a high state of excitement, Bruce drew his dagger, and stabbed Comyn in front of the high altar, and then rushed out of the church to take horse, but one of his retainers, named Kirkpatrick, asked him the cause of his agitation, Bruce replied, "I doubt I have slain Comyn." "You doubt," cries Kirkpatrick, "I mak sicker,"

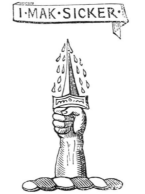

KIRKPATRICK, OF CLOSEBURNE..

"I'll make sure;" thus saying, Kirkpatrick went back into the church, and stabbed Comyn again to the death, and then joined Bruce; thus—

"Vain Kirkpatrick's bloody dirk,
Making sure of murder's work."
SCOTT.

In memory of this event, this Roger de Kirkpatrick, of Closeburne, assumed for his crest a hand grasping a dagger, dropping drops of blood, and the motto, "I mak sicker," or "I'll make sure," and it is an interesting fact that the present Empress of the French, Eugénie, is a direct descendant of this Roger de Kirkpatrick, of Closeburne. The crest and motto are here given.

Again, the Duke of Northumberland's motto, "Esperance en Dieu," "Hope in God," has been the subject of some excellent reflexions. The fiery Harry Hotspur made a distinguished figure in the war of the Roses, and Shakspeare alludes to the Percy motto in the passage, "Now Esperance Percy and set on," and a writer in the "Quarterly Review" has remarked, in allusion to the Percy motto, "At one time the Percy was the provincial monarch of unmeasured lands, the lord of impregnable fortresses, and the chief of countless vassals. At another time he was the tenant of a prison, from which there was seldom any exit but that of death. These vicissitudes must have taught the Percy the instability of all human greatness, and that there is no real security, but in 'Esperance en Dieu,' 'Hope in God.'" The family of Cobbe of Newbridge, bearing swans in their arms, and the motto "Moriens Cano," "I Sing in Death," serves to illustrate a fiction of the poets, that swans always sing when they are dying, and Shakspeare has beautifully embodied the thought in the passage

"He makes a swan-like end,
Fading in music."

The arms and motto of Cobbe of Newbridge, County of Dublin, are here given.

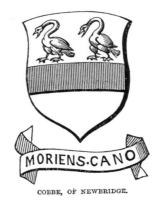

COBBE, OF NEWBRIDGE.

Of royal crests, the first example we have of a crest borne by the monarchs of England is that of King Edward III., who bore for his crest a lion *passant*, but placed on a *chapeau*, or cap of estate, above the helmet; the same crest was borne by his son, Edward the Black Prince. His grandson, Richard II., placed the lion on the top of the imperial crown, and it has continued to be thus borne from the time of Richard II. down to the present, a period of four

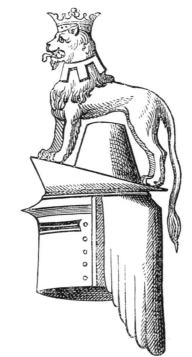

CREST OF EDWARD THE BLACK PRINCE.

hundred and fifty years, without variation. A sketch of the crest of Edward the Black Prince, as borne upon the *chapeau*, with the helmet and *lambrequin*, from his tomb at Canterbury Cathedral, is here given, as also a sketch of the royal crest as now borne.

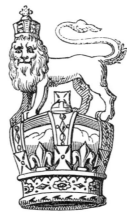

THE ROYAL CREST.

FROM the practice of the tournaments, then, several important features in Heraldry, although in existence long before, became either more accurately defined, or more stringently carried out. The crest, which previously was but an occasional appendage to the arms of a very few individuals, became a constituent feature of the blazonry, and was added to the shield of every gentleman bearing arms. Again, the colours of the torse or wreath, which before were arbitrary, became fixed upon a well-defined principle, drawn from the metal and colours in the shield. The same law was also applied to the colours of the *lambrequin* or *mantelet*, and those laws are not only still binding, but where good taste prevails the same rules also guide the choice of colours for the attire of the liveried attendants. The usages of chivalry thus induced among the gentry of the middle ages an ardent attachment to their armorial bearings, and a most vigilant tenacity in the accurate emblazonment of them, so much so, that any attempt to infringe or tamper with a gentleman's coat of arms was resented as strenuously as a personal insult, or an encroachment on his real property. A knowledge of the "gentle science of armorie" was then a part of the education of every gentleman, and of every prince; and although we are sometimes told

the age of chivalry is gone, yet there can be no question that to the prevalence of these feelings among our ancestors in bygone days, may be traced in a large degree that high sense of honour and gallant bearing which still marks the true English gentleman.

ARMS OF ALLIANCE.

BATON.
Arms of Fitzroy, Duke of Grafton.

William Bruges,
Garter King of arms
(1420).